date me

KRISTIN BEALE

NEW YORK

LONDON • NASHVILLE • MELBOURNE • VANCOUVER

date me

Published in New York, New York, by Morgan James Publishing. Morgan James is a trademark of Morgan James, LLC. www.MorganJamesPublishing.com

The Morgan James Speakers Group can bring authors to your live event. For more information or to book an event visit The Morgan James Speakers Group at www.TheMorganJamesSpeakersGroup.com.

ISBN 9781683508816 paperback
ISBN 9781683508823 eBook
Library of Congress Control Number: 2017918561

Cover Design by:
Megan Whitney Dillon
megan@creativeninjadesigns.com

Interior Design by:
Christopher Kirk
www.GFSstudio.com

In an effort to support local communities, raise awareness and funds, Morgan James Publishing donates a percentage of all book sales for the life of each book to Habitat for Humanity Peninsula and Greater Williamsburg.

Get involved today! Visit
www.MorganJamesBuilds.com

I'm young, single, and in a wheelchair. In most people's minds, my wheelchair seems to define me; people are either scared of it or think it's a bigger deal than it is. But I'm just a normal girl. I'm a young, single woman who happens to be sitting down.

Still, for better or worse, my wheelchair sets me apart. In dating—it's for worse. In meeting new people—it's for worse. In maneuvering around the city I live and grew up in—it's for worse.

But there are benefits.

My wheelchair placard gets me great parking spots. I skip lines at theme parks like I'm royalty. I occupy the biggest bathroom stalls, and my college dorm room was legally and exceptionally larger than my peers. As for dating and finding a man who loves me, that'll happen when I least expect it—at least that's what people say. Good thing I'm not in a hurry.

Date Me tells the stories of my crazy family; the unique and often lousy ways people interact with me because of my disability; and my attempts, often failed, at dating in a wheelchair with a strained, but ongoing determination not to give up.

Enjoy.

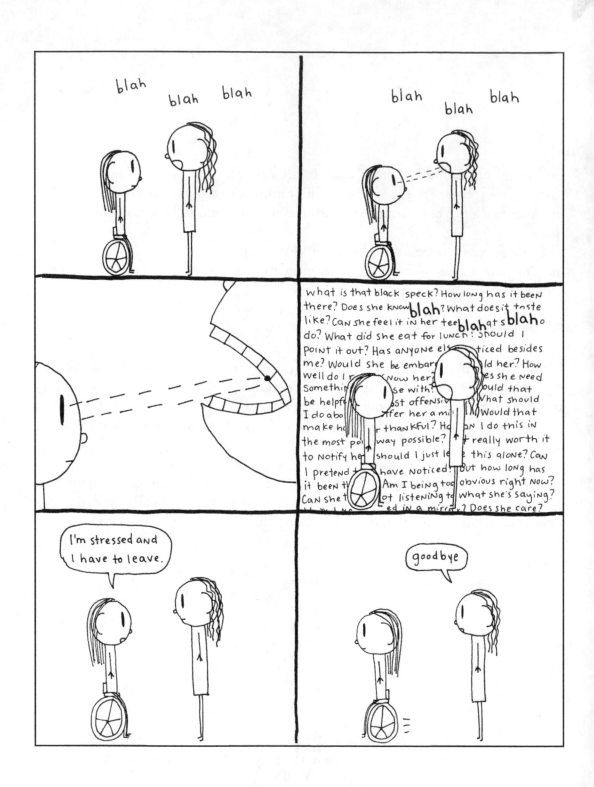

KRISTIN BEALE

6

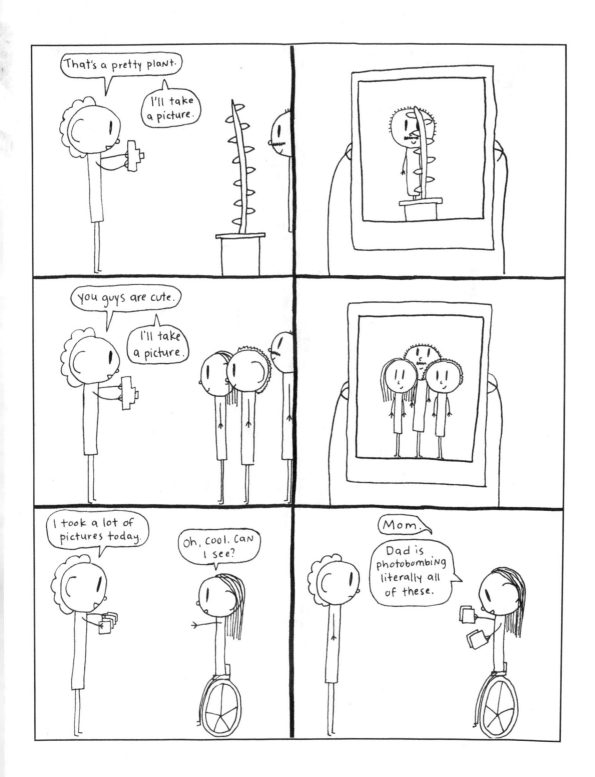

date me

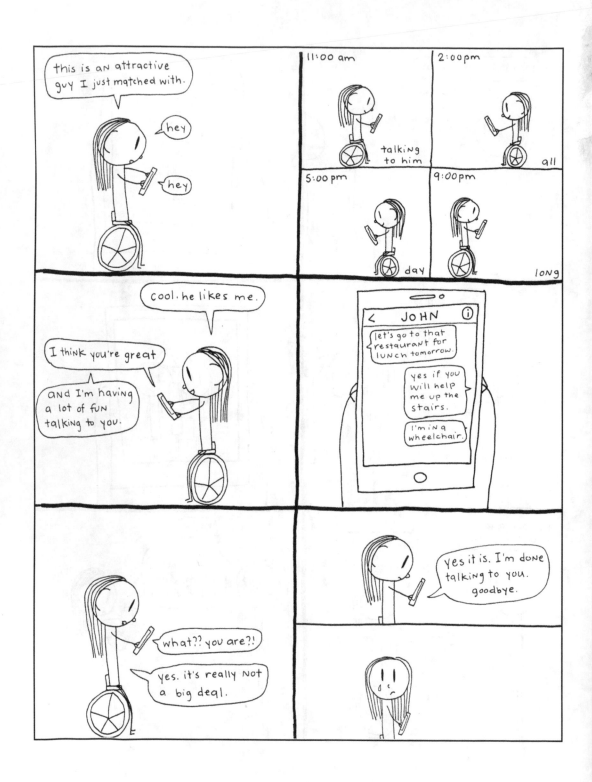

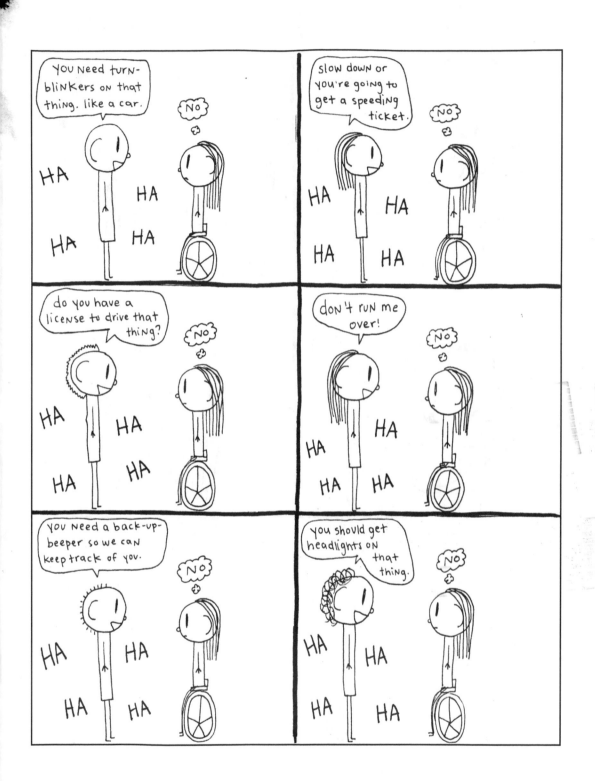

date me

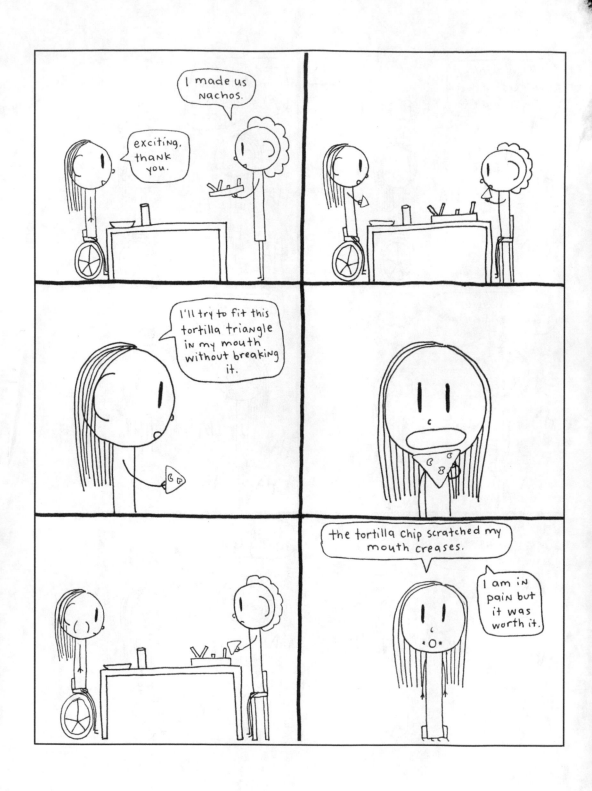

KRISTIN BEALE

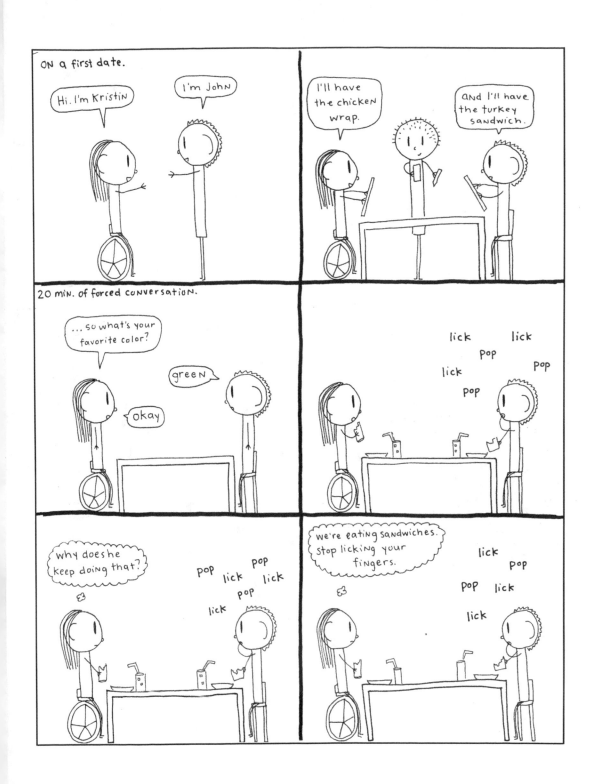

date me

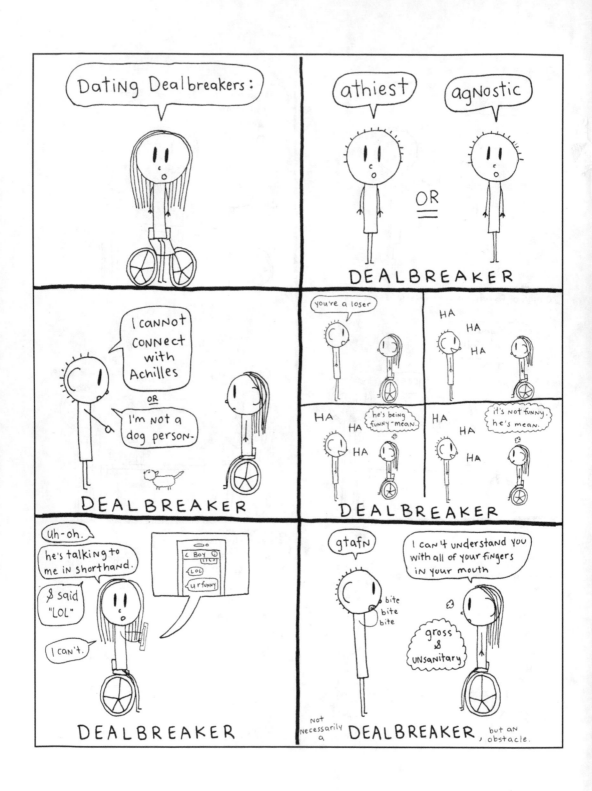

KRISTIN BEALE

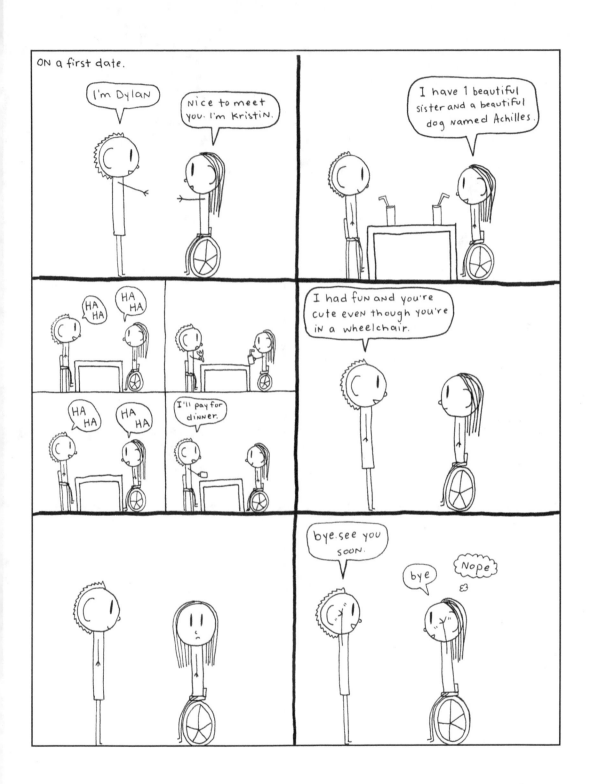

date me

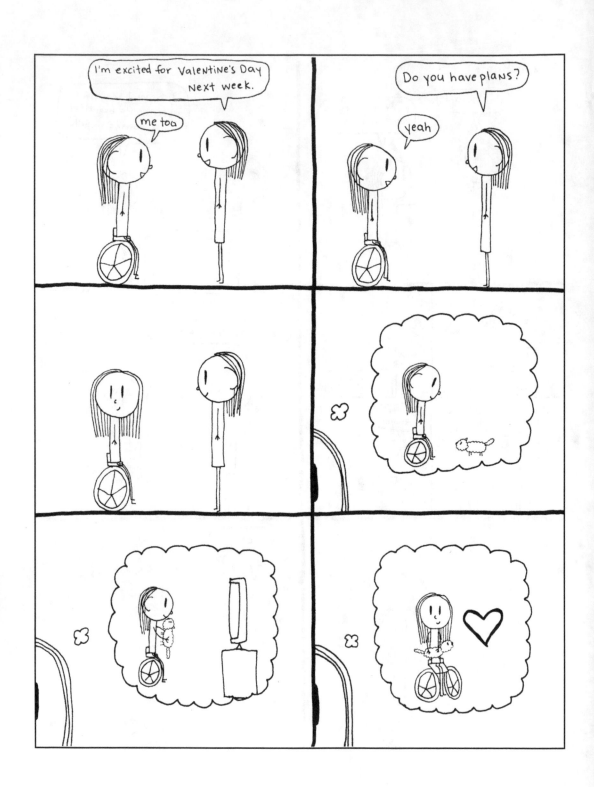

KRISTIN BEALE

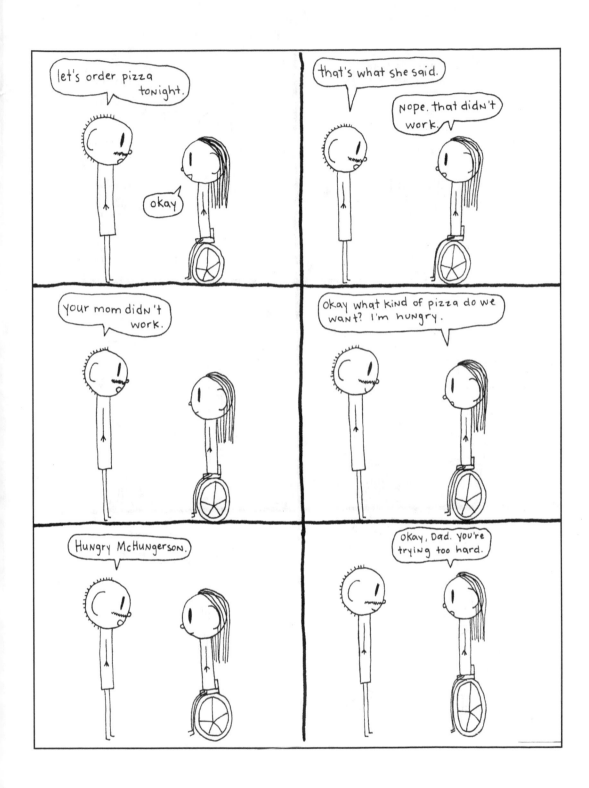

date me

17

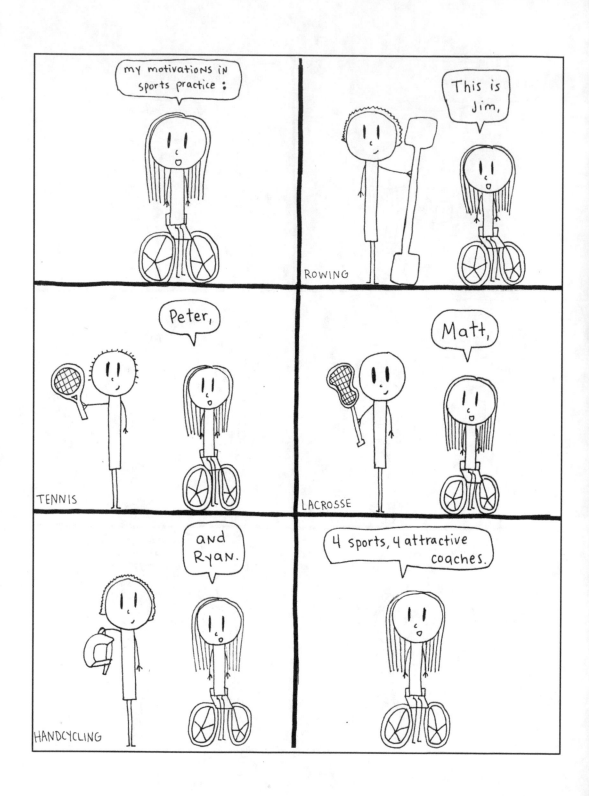

KRISTIN BEALE

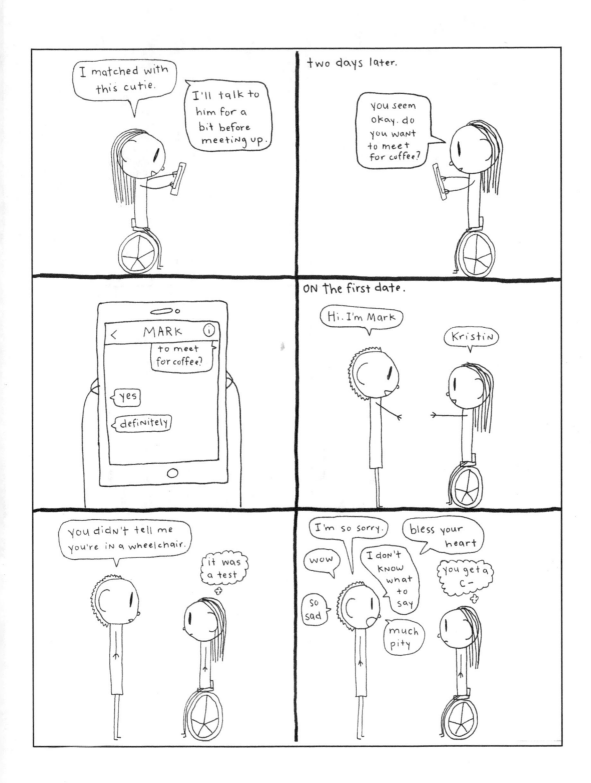

date me

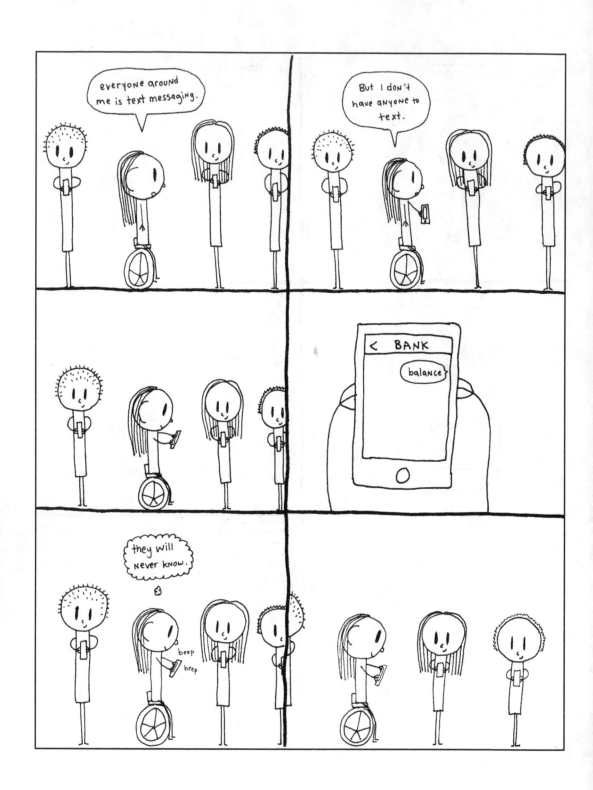

KRISTIN BEALE

20

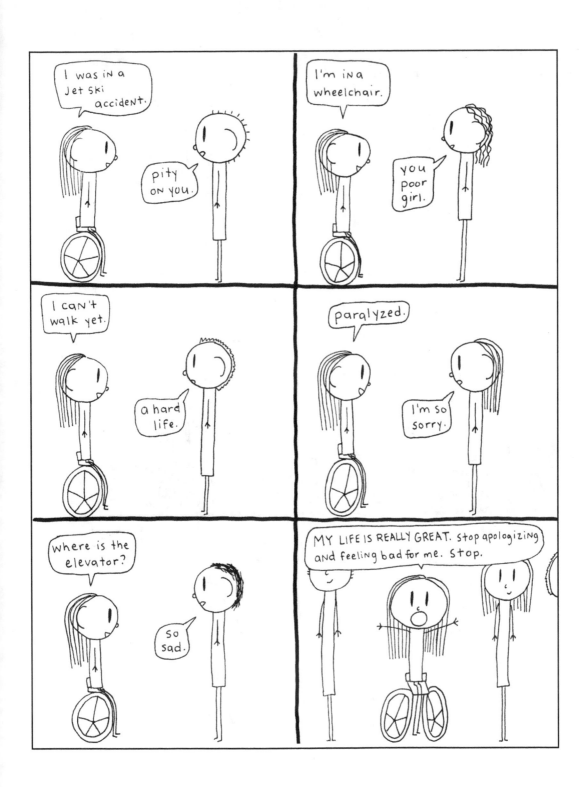

date me

21

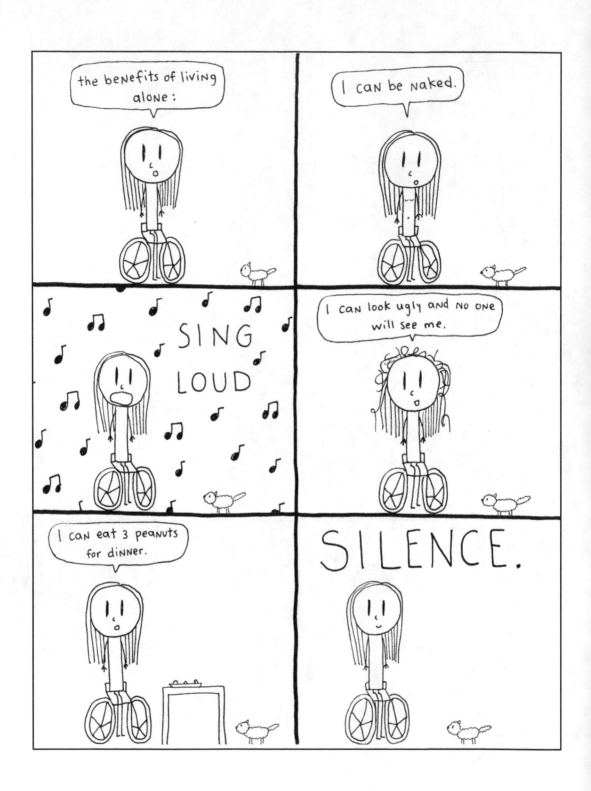

KRISTIN BEALE

22

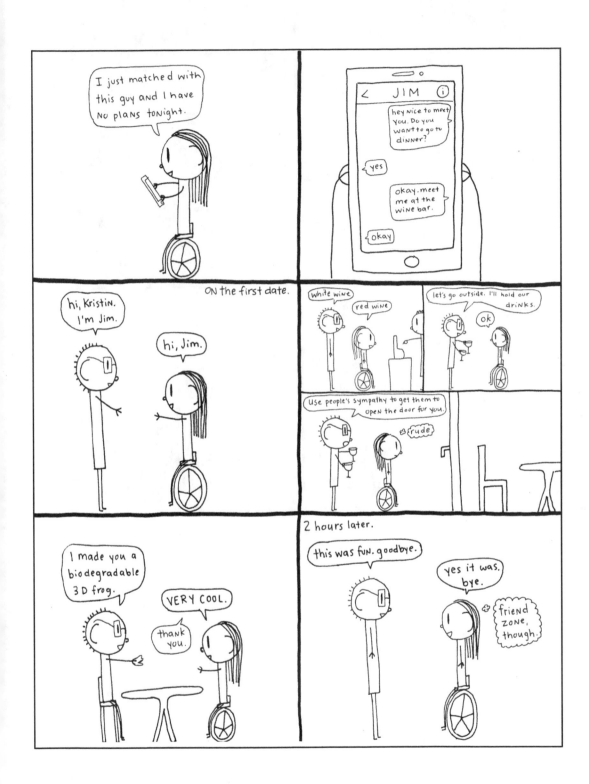

date me

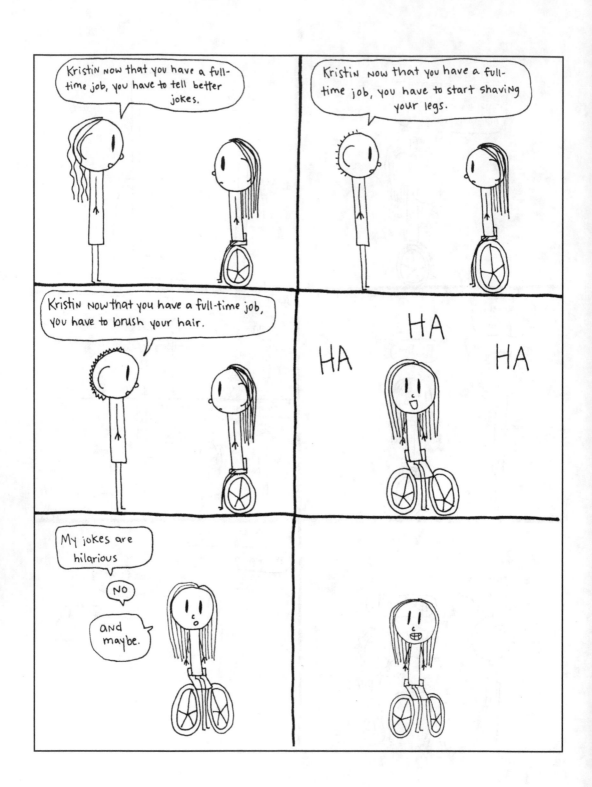

KRISTIN BEALE

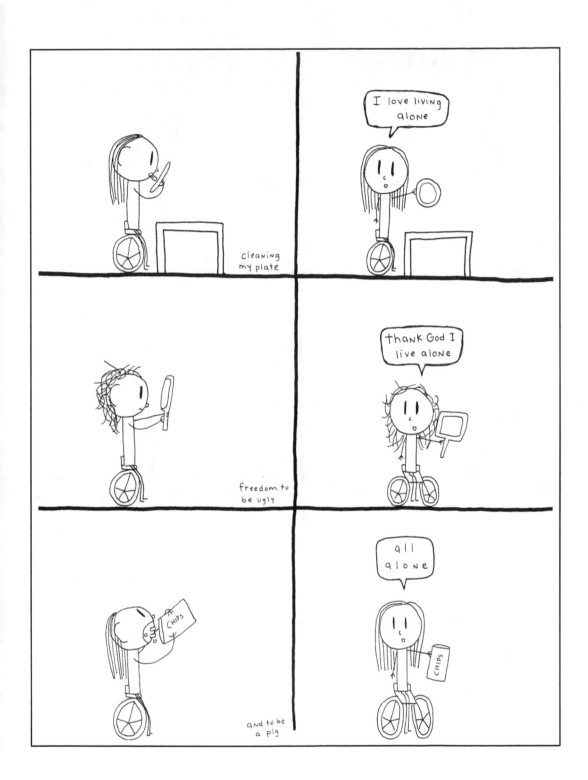

date me

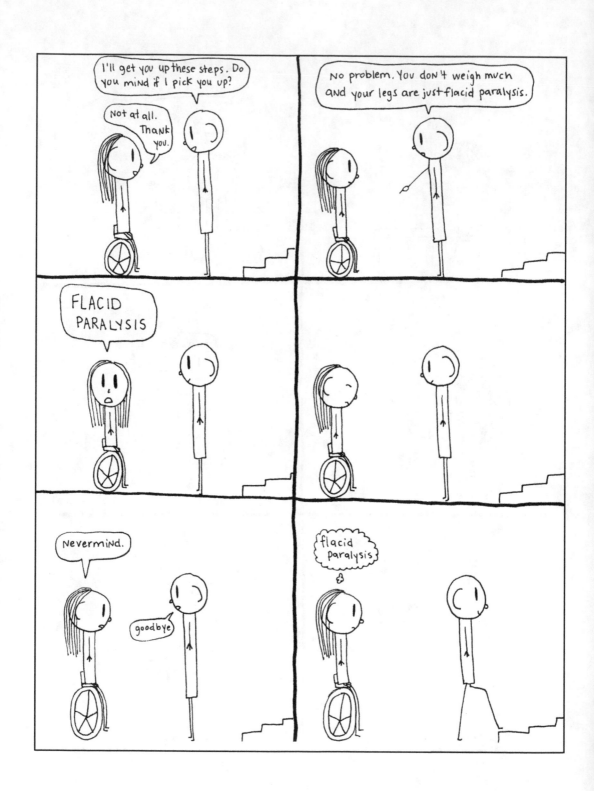

KRISTIN BEALE

26

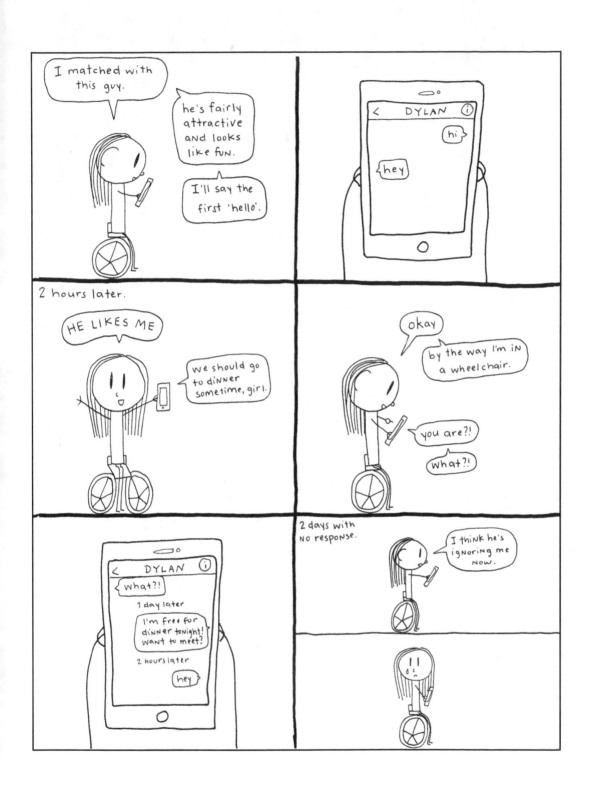

date me

27

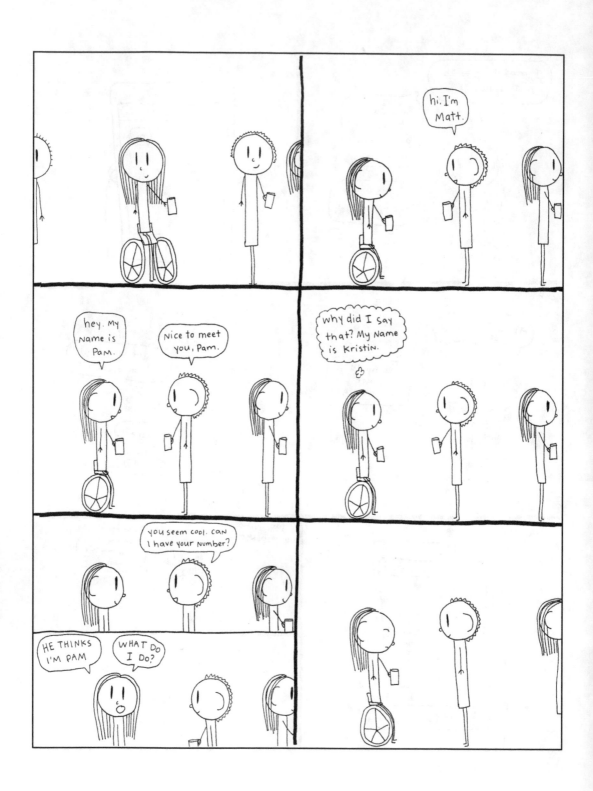

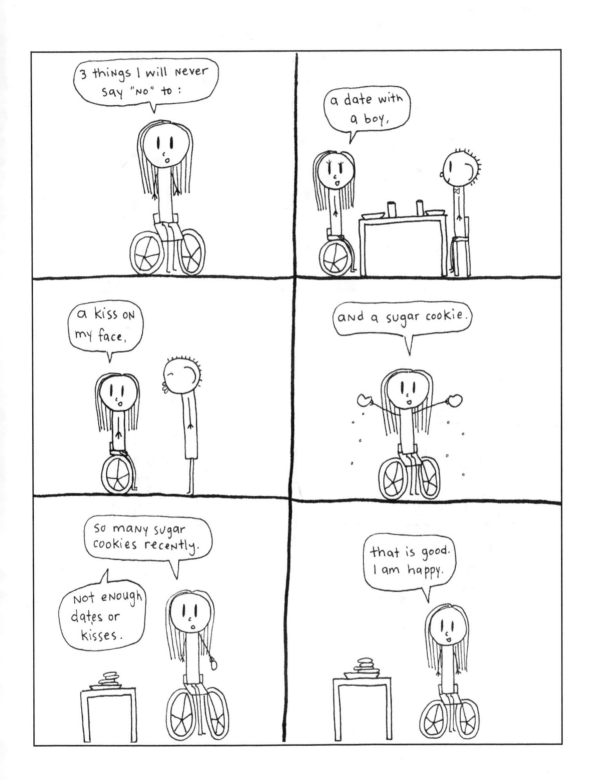

date me

29

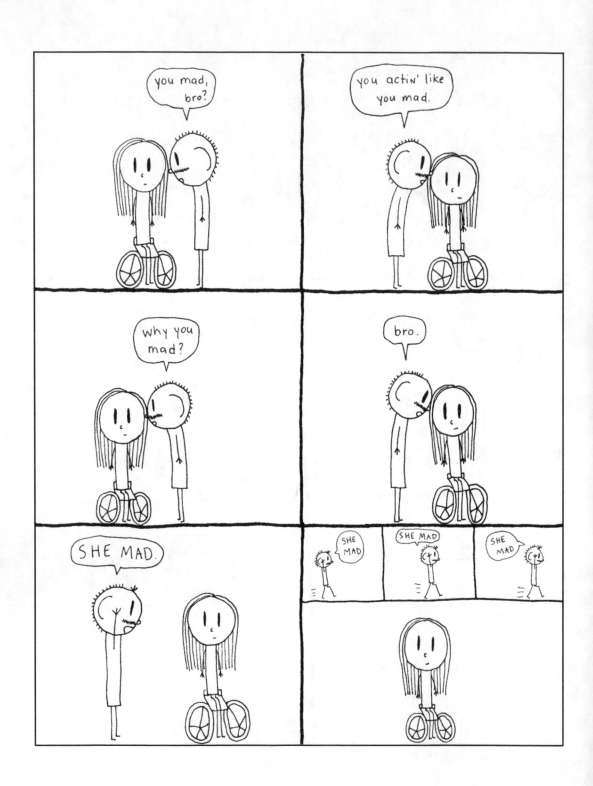

KRISTIN BEALE

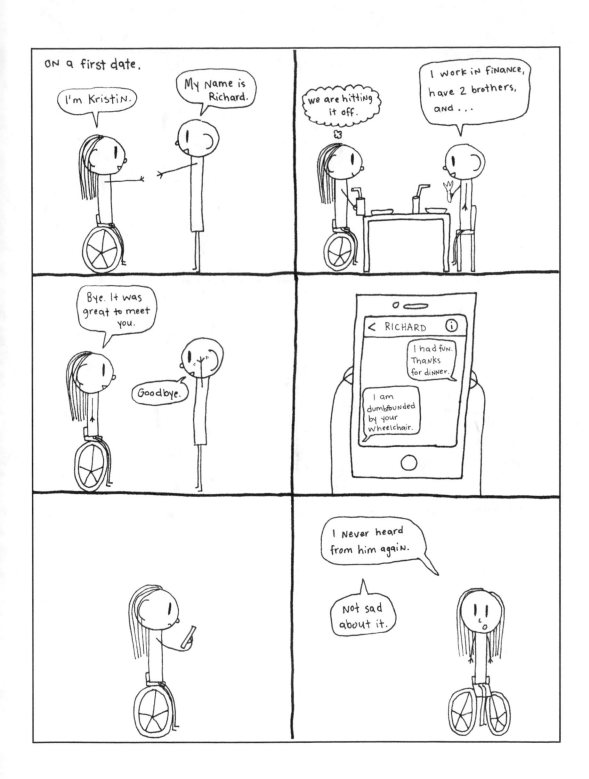

date me

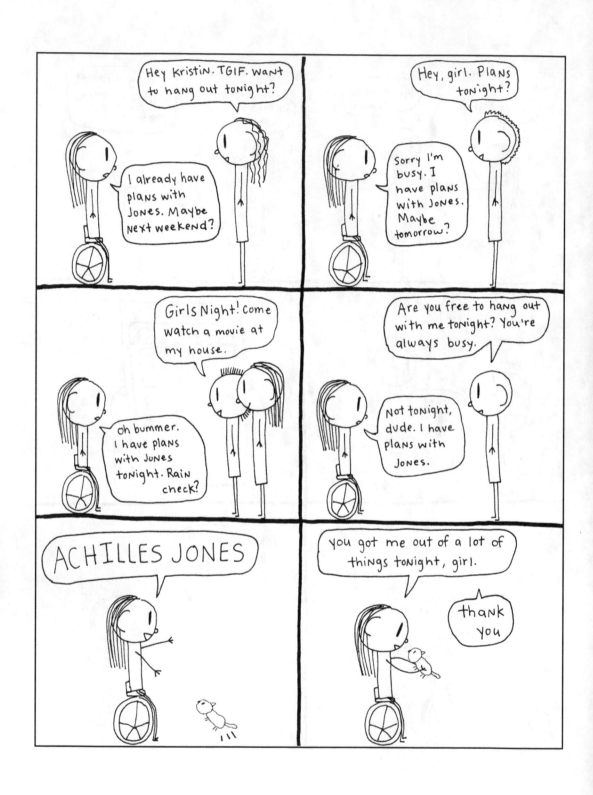

KRISTIN BEALE

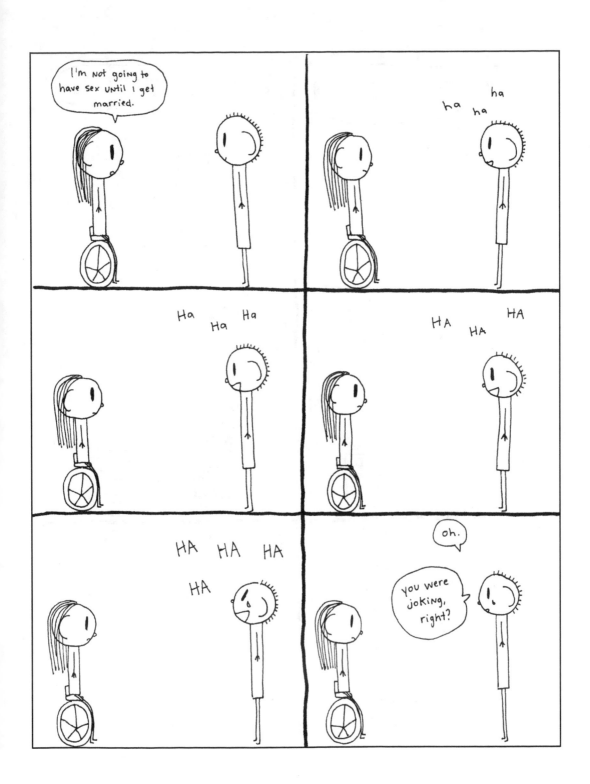

date me

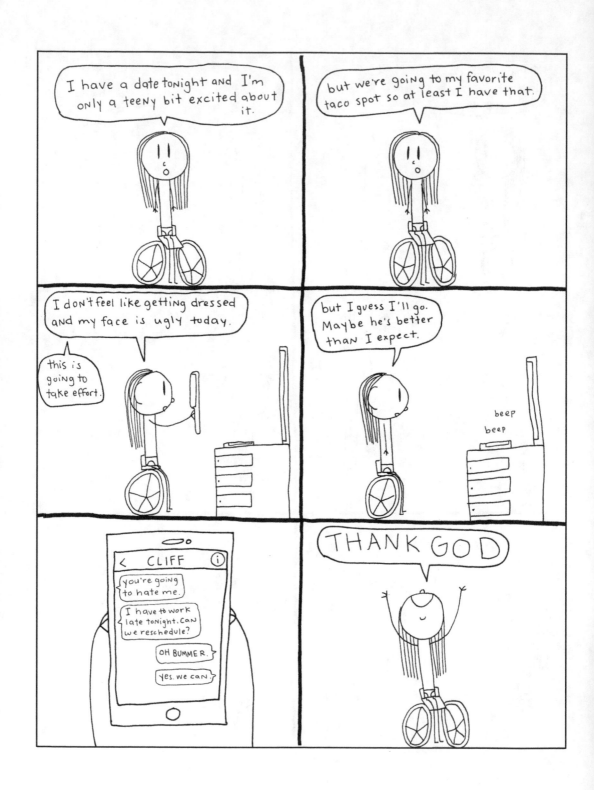

KRISTIN BEALE

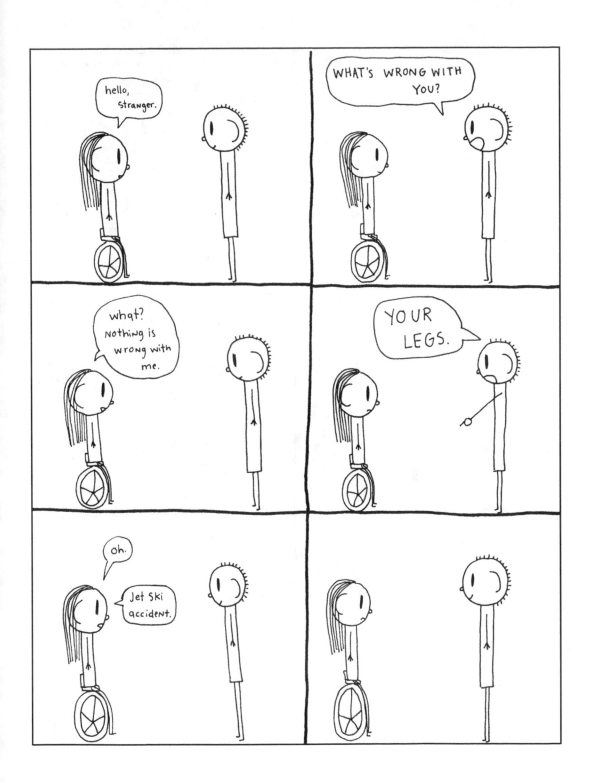

date me

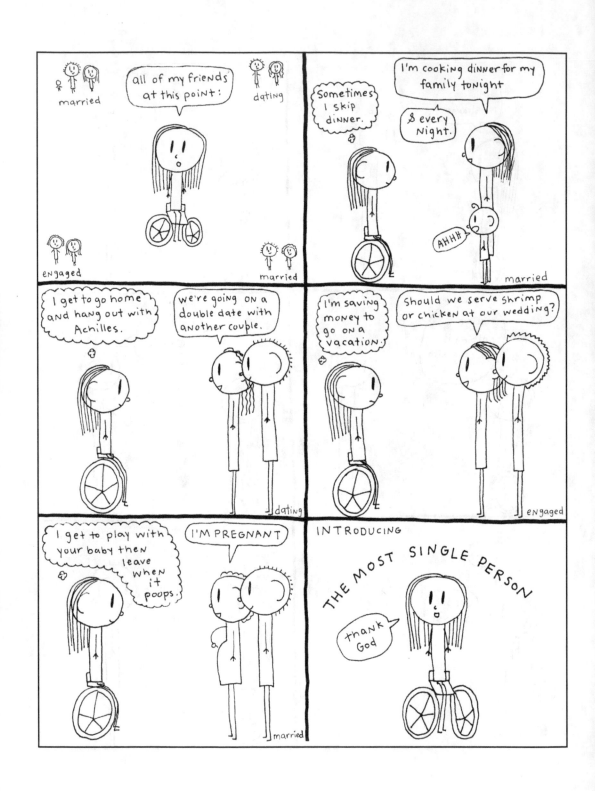

KRISTIN BEALE

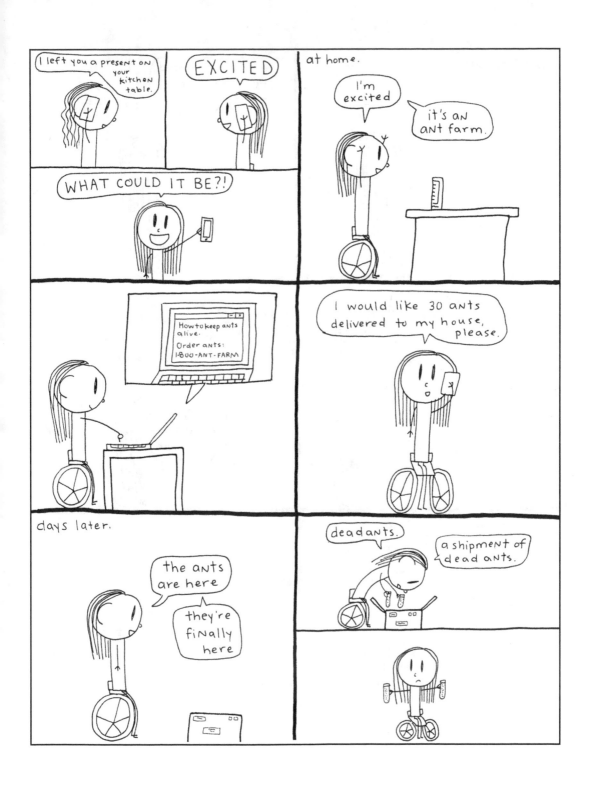

date me

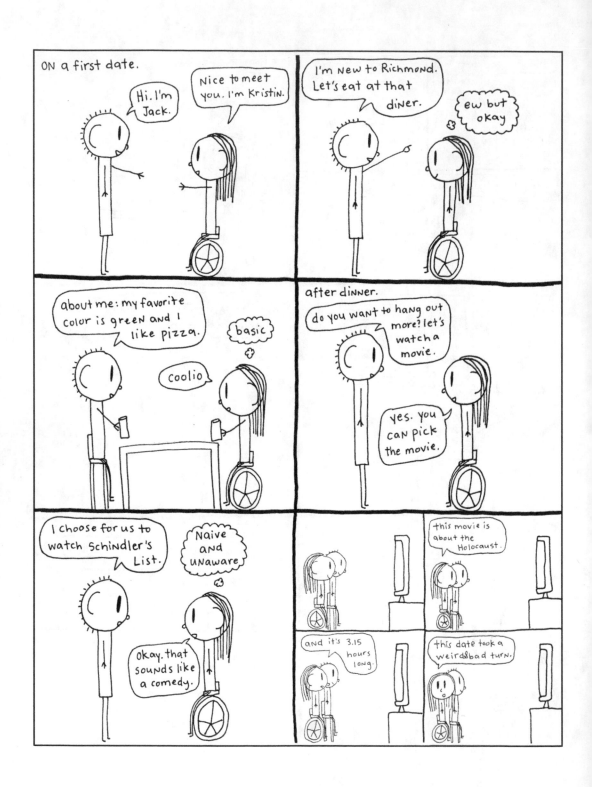

KRISTIN BEALE

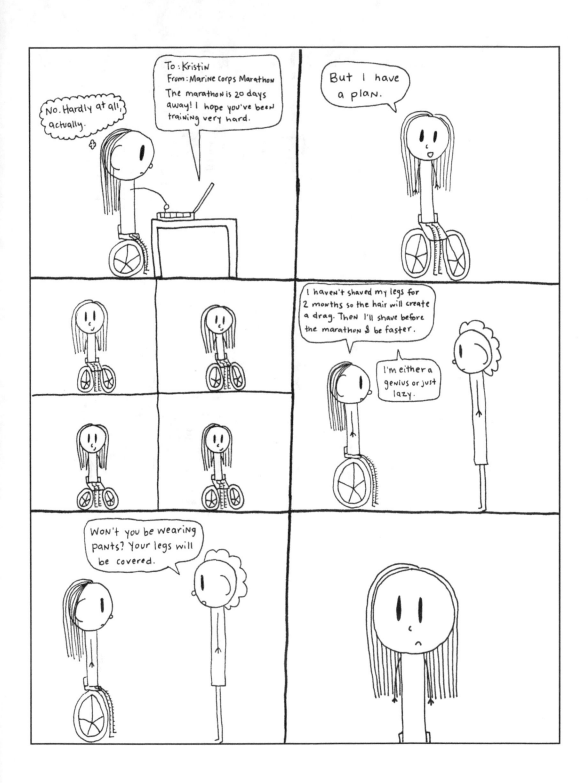

date me

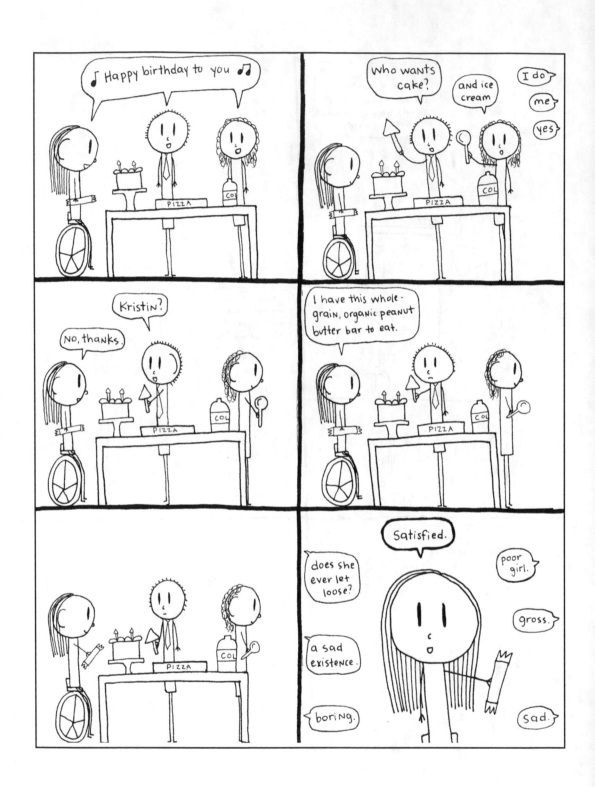

KRISTIN BEALE

40

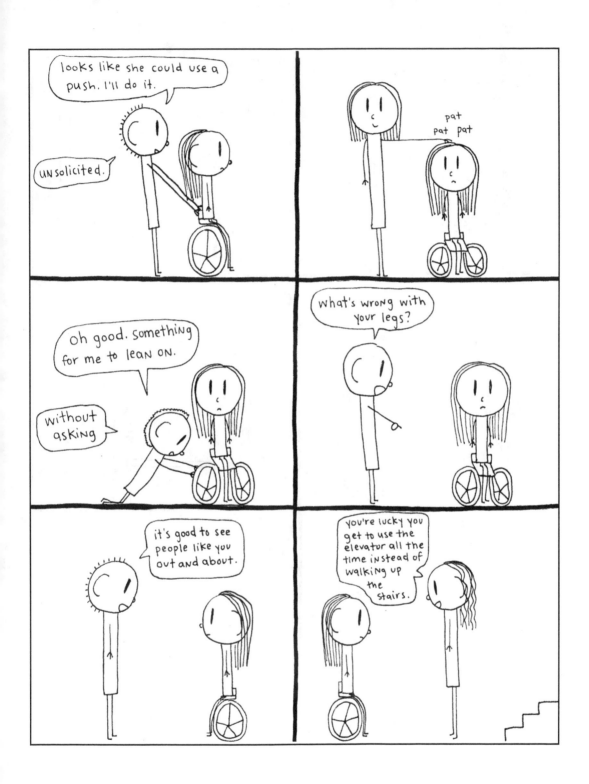

date me

41

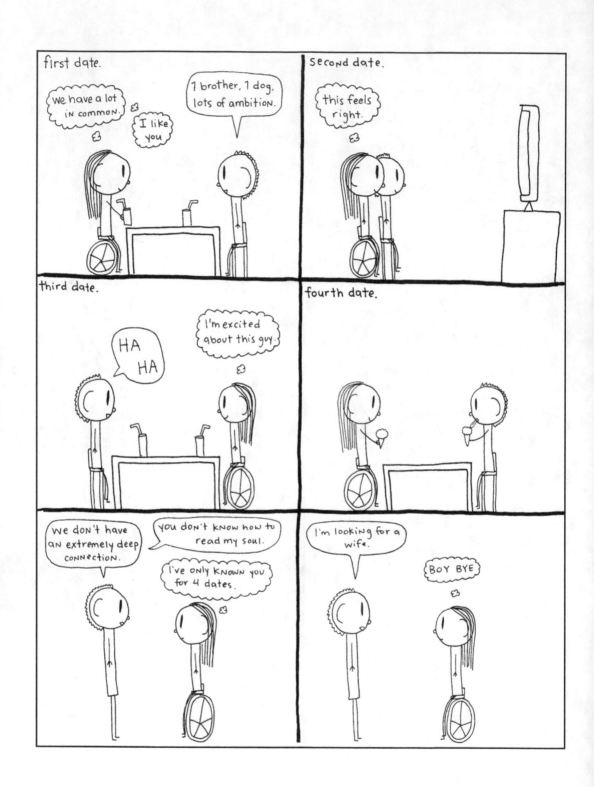

KRISTIN BEALE

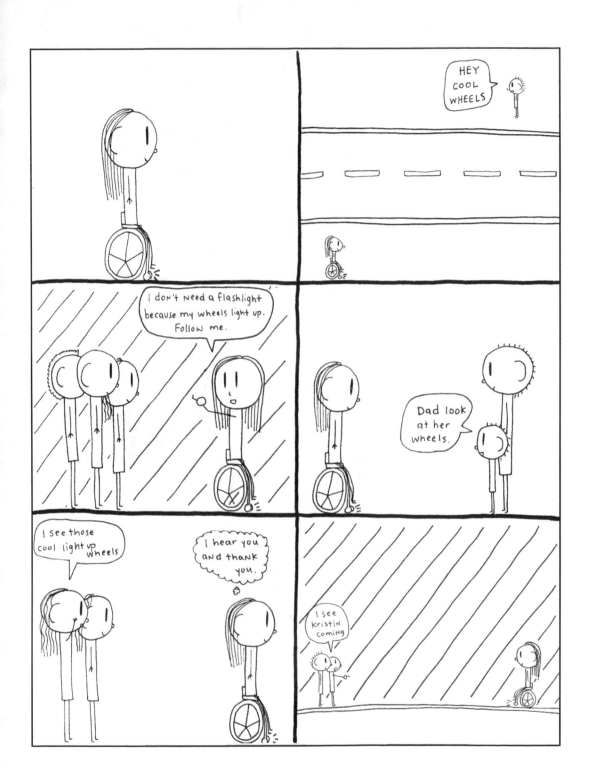

date me

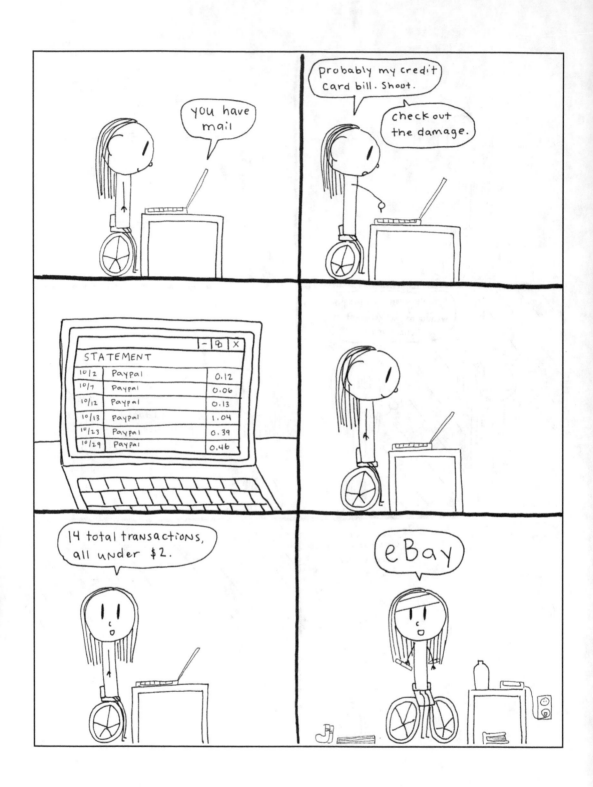

KRISTIN BEALE

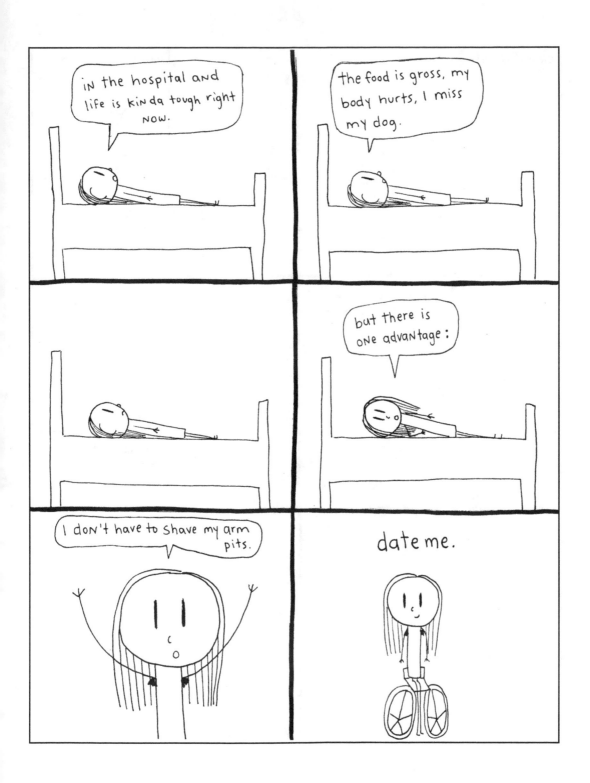

date me

45

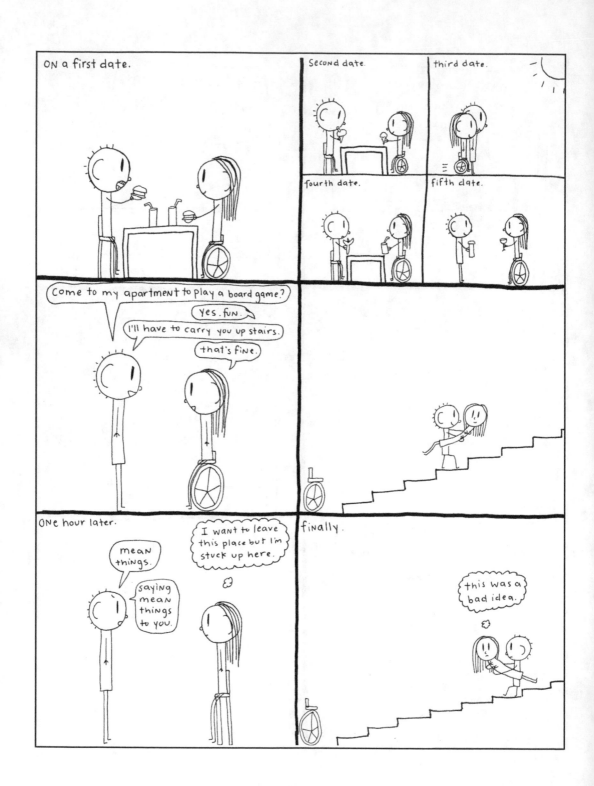

KRISTIN BEALE

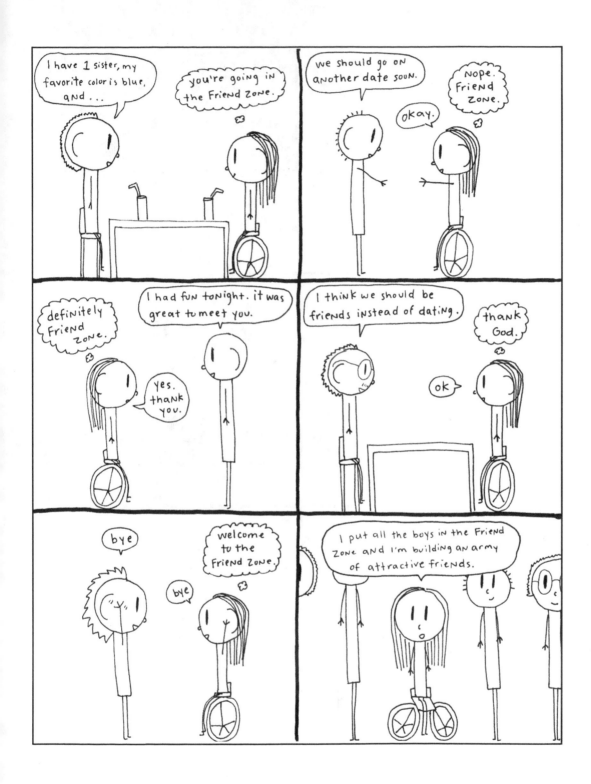

date me

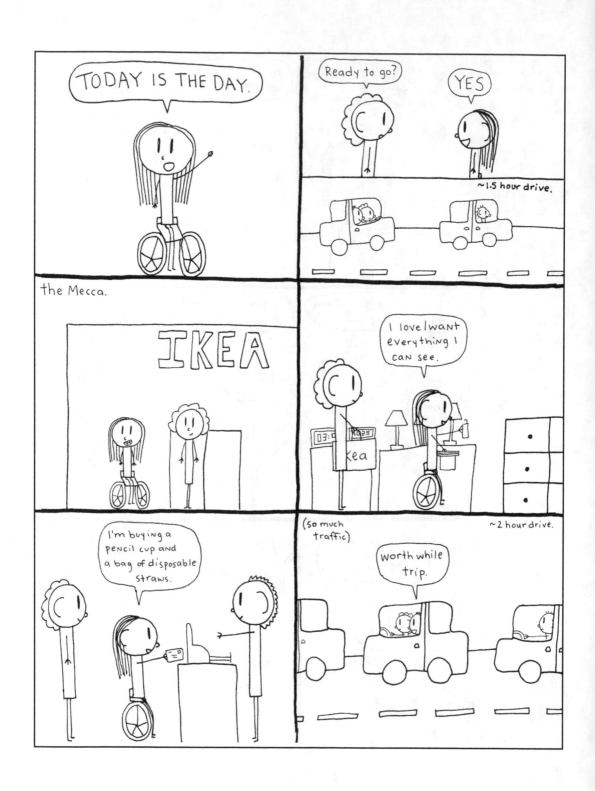

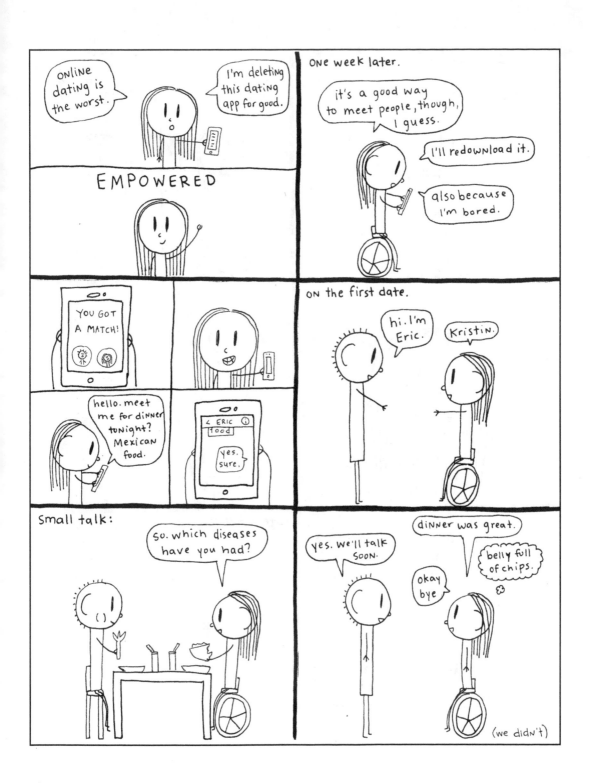

date me

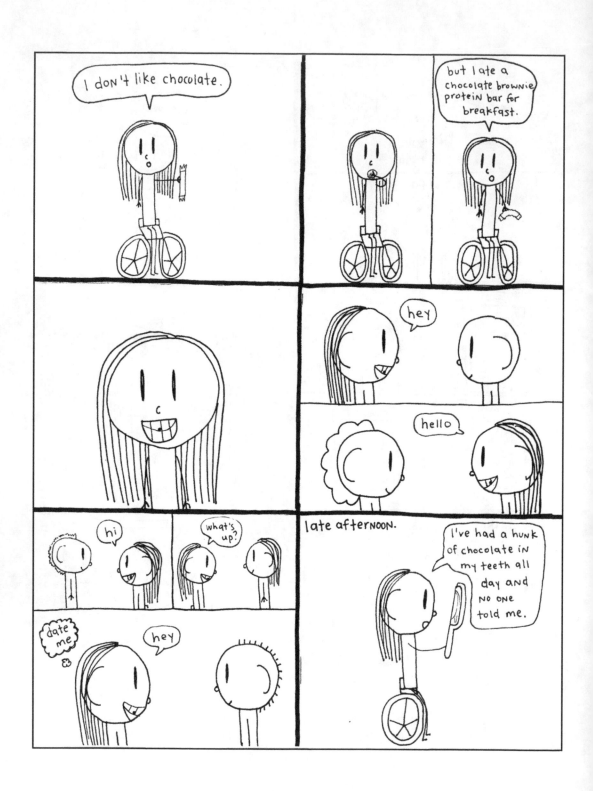

KRISTIN BEALE

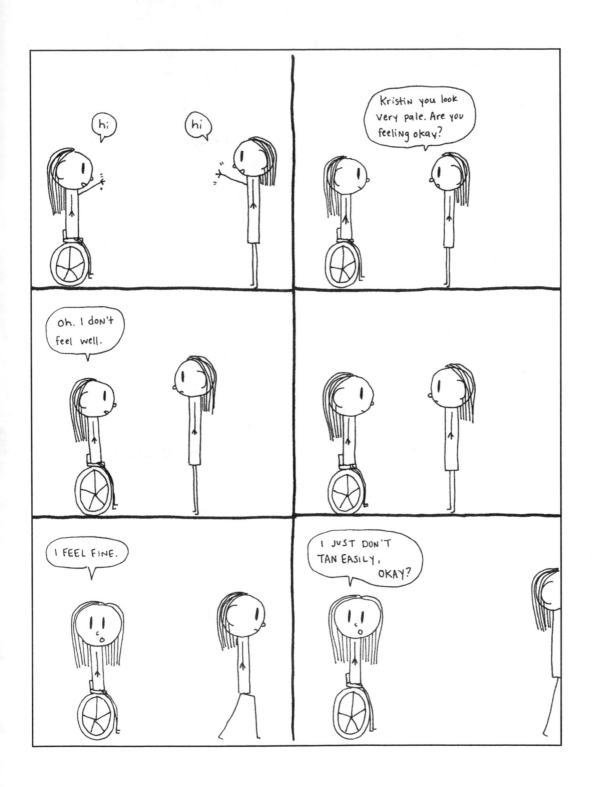

date me

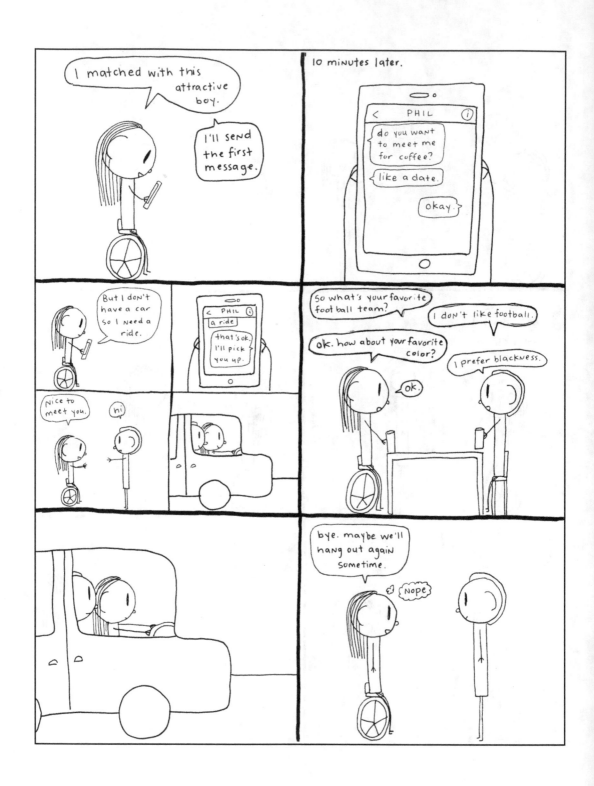

KRISTIN BEALE

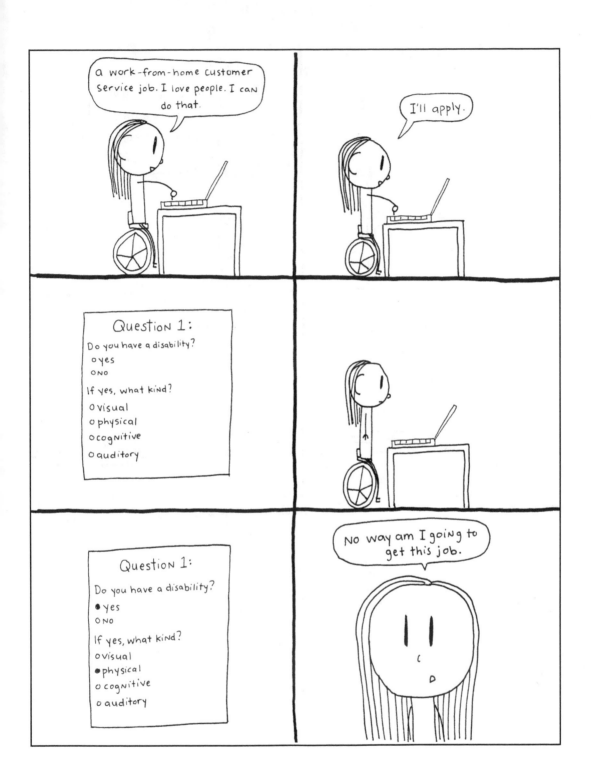

date me

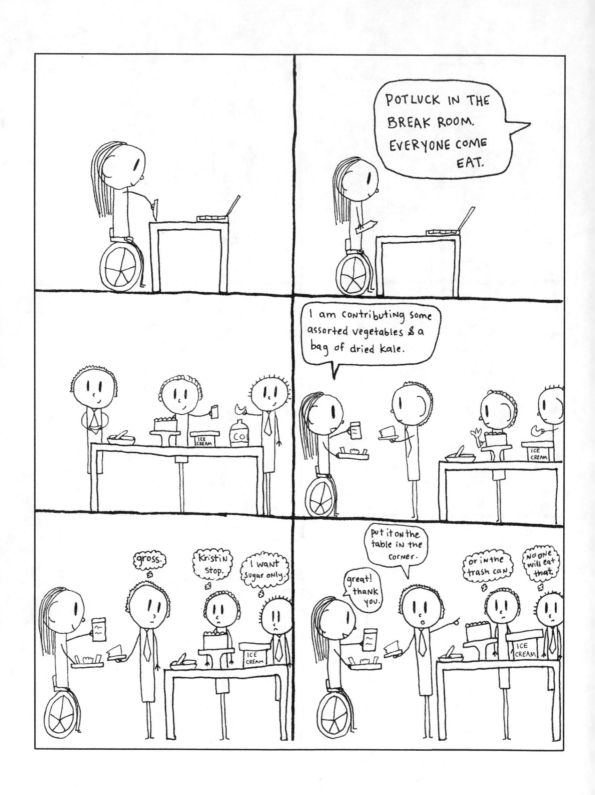

KRISTIN BEALE

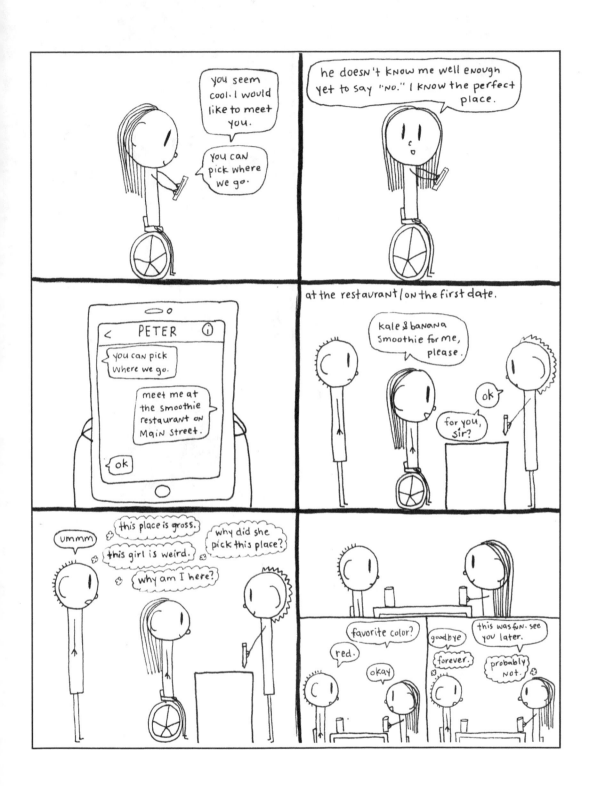

date me

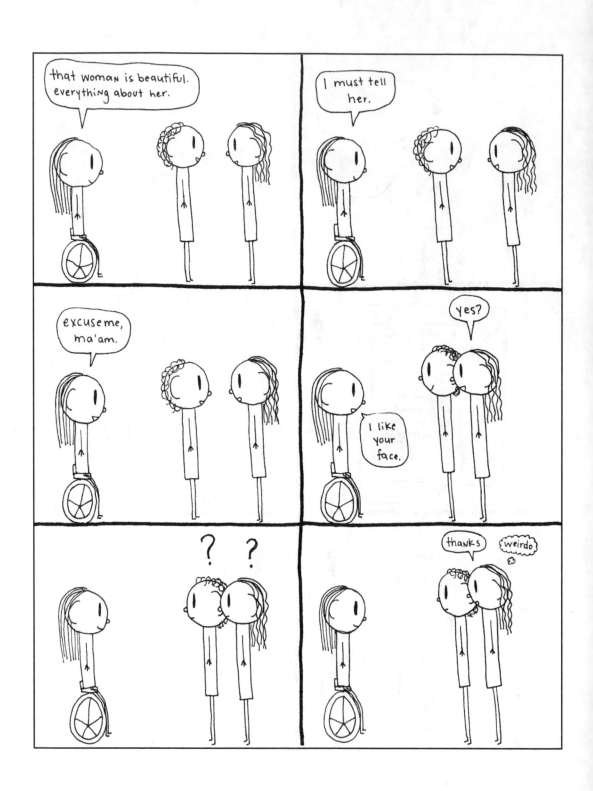

KRISTIN BEALE

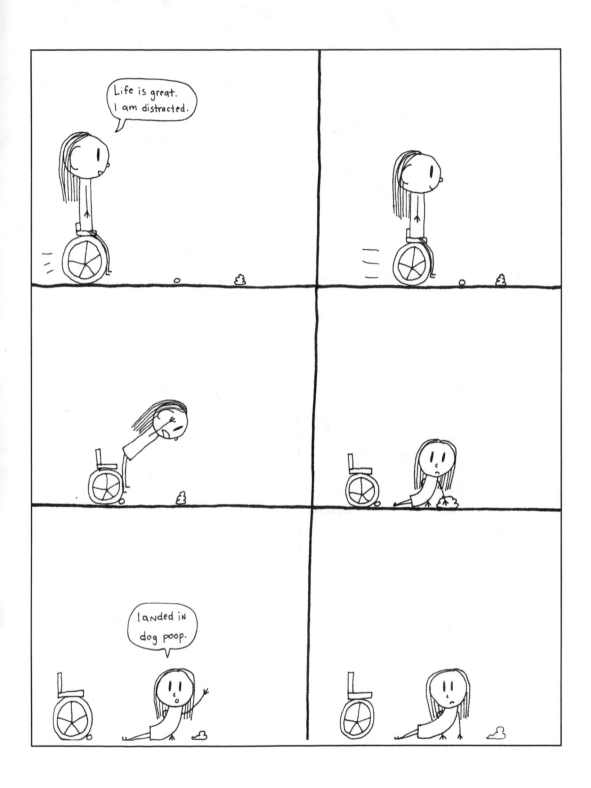

date me

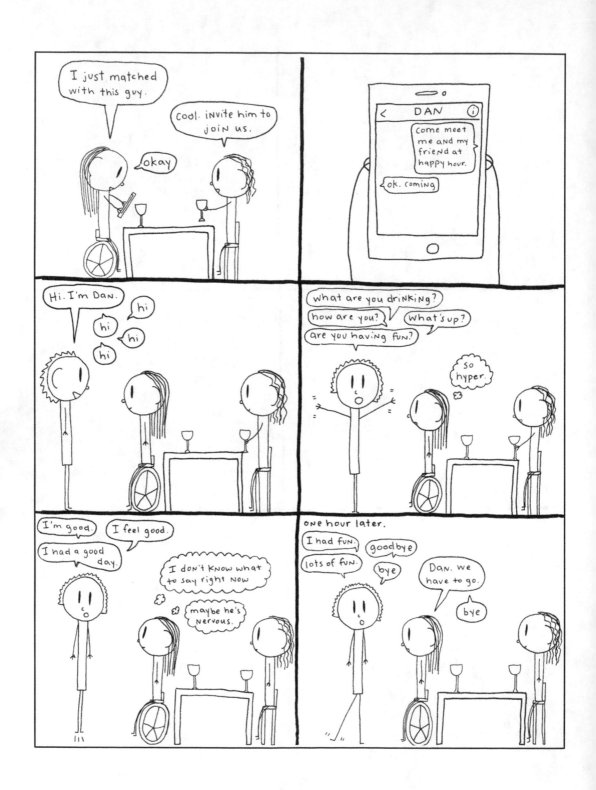

KRISTIN BEALE

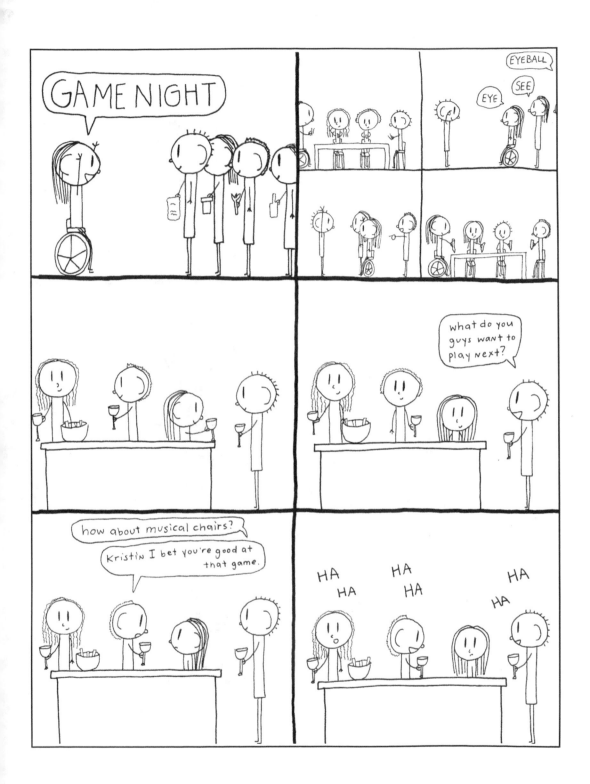

date me

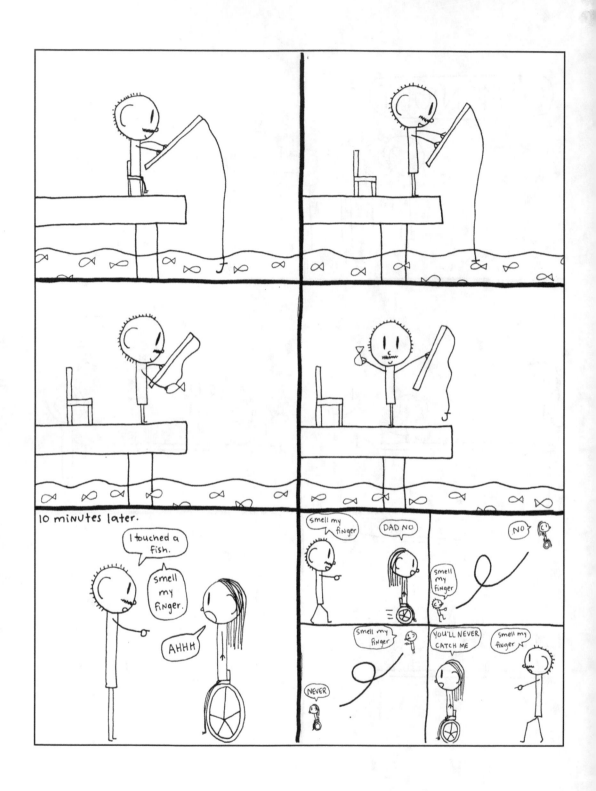

KRISTIN BEALE

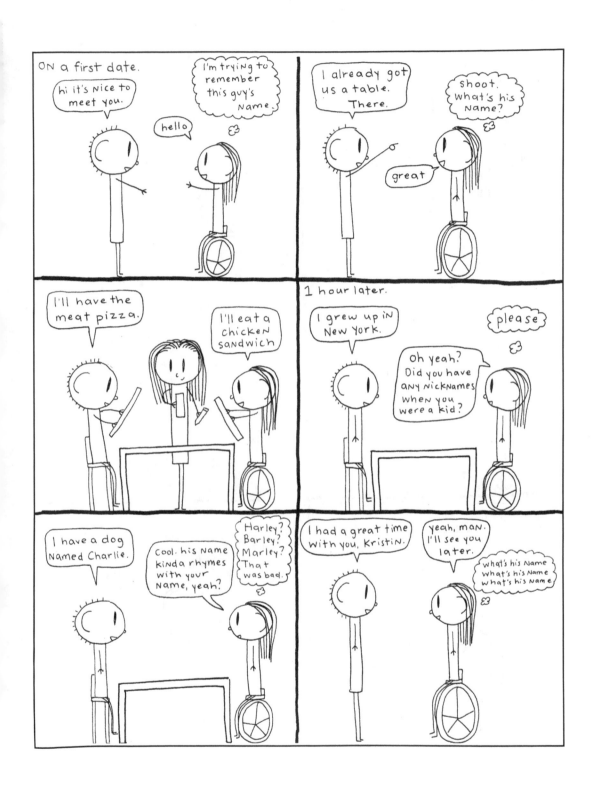

date me

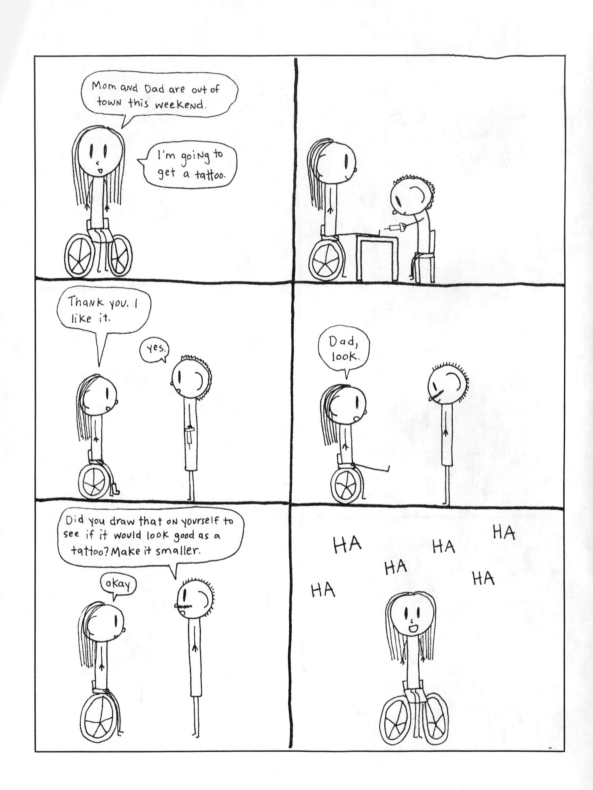

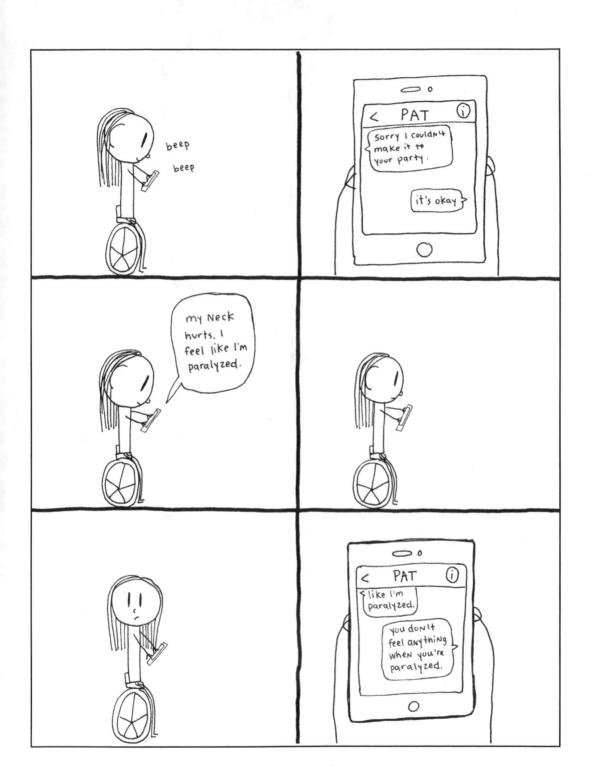

date me

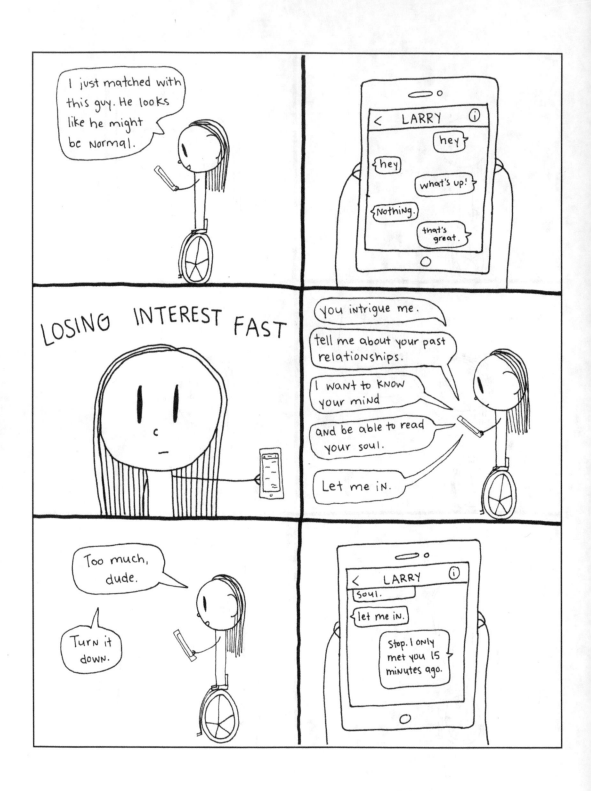

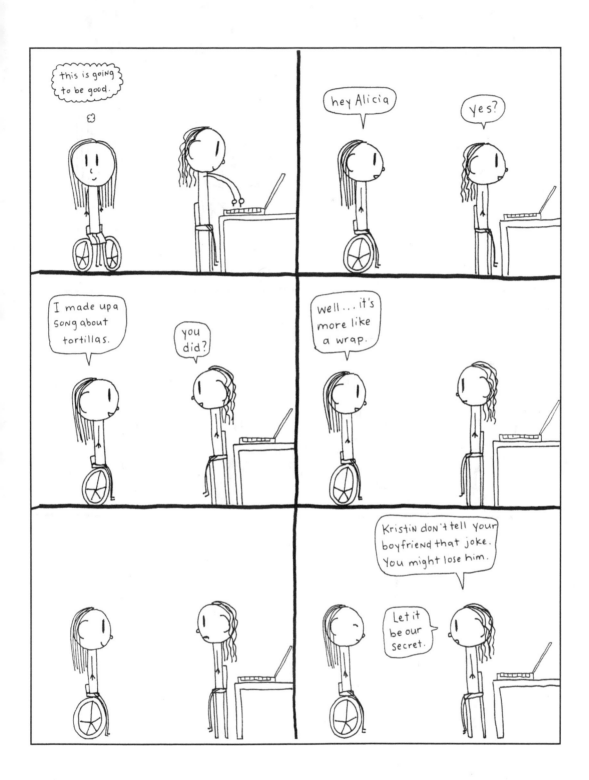

date me

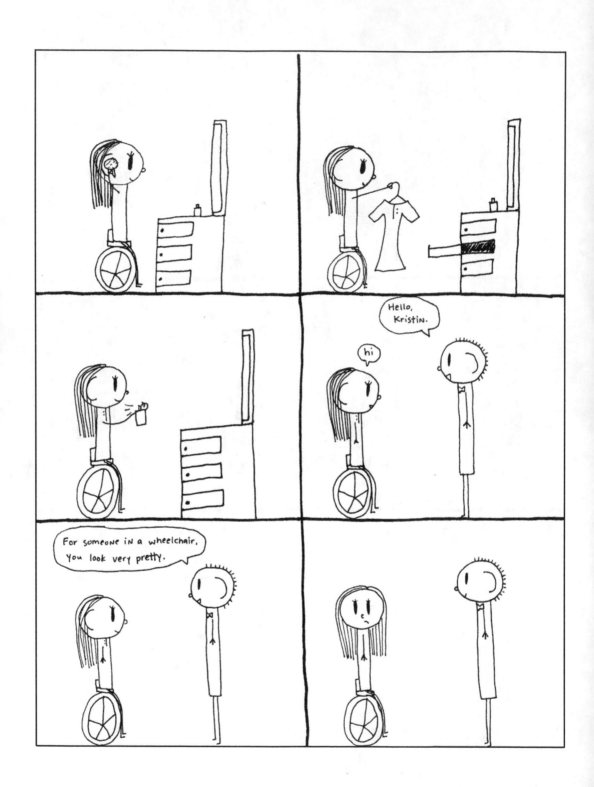

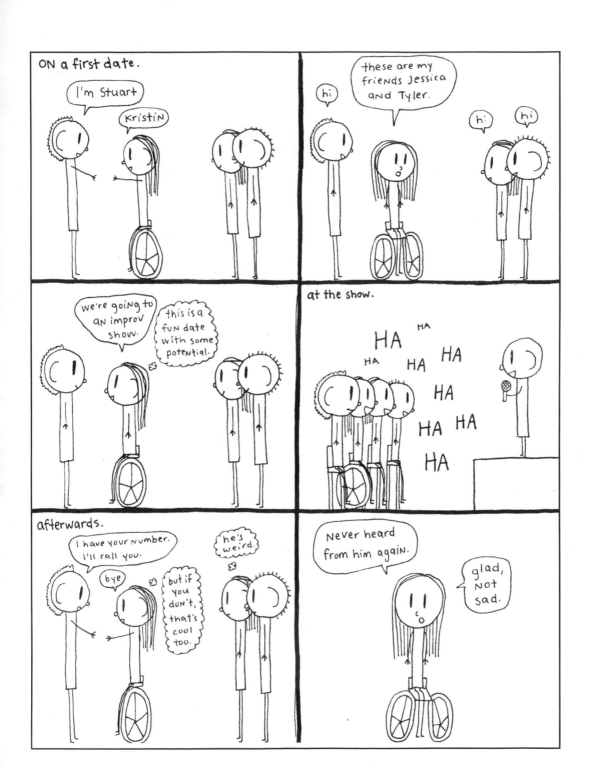

date me

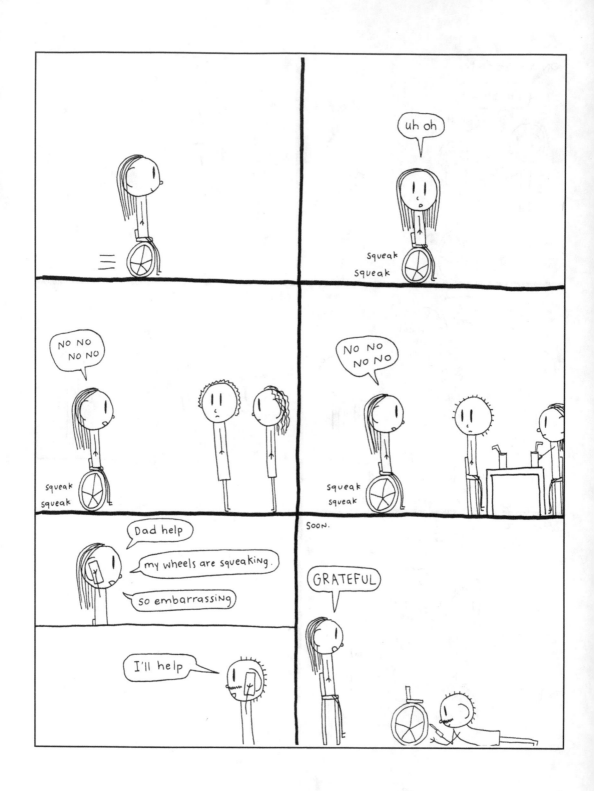

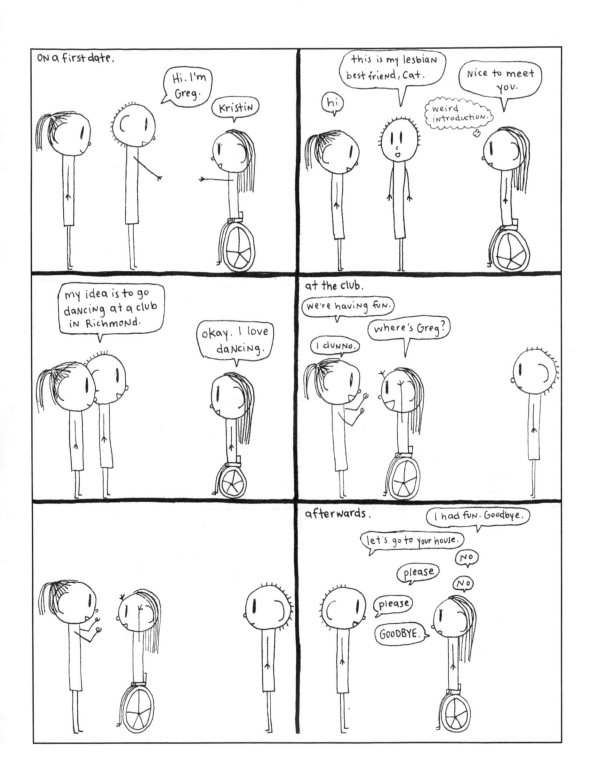

date me

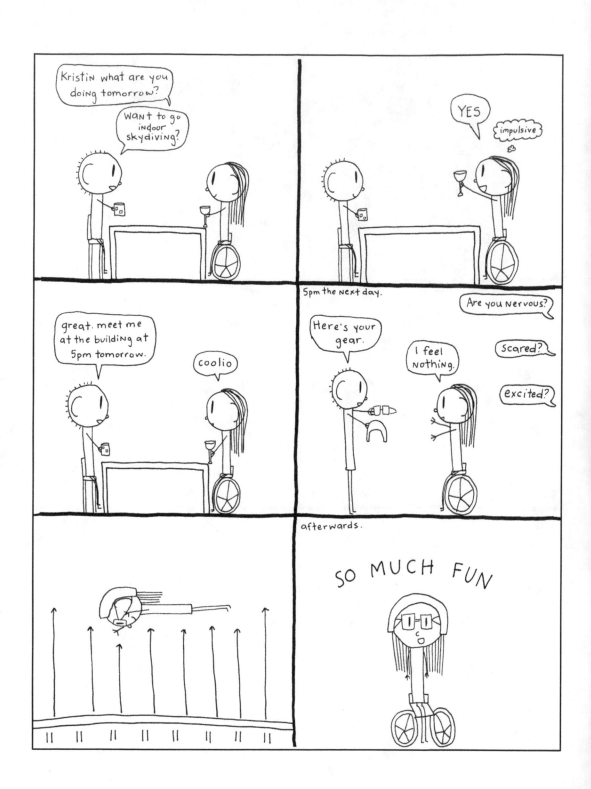

KRISTIN BEALE

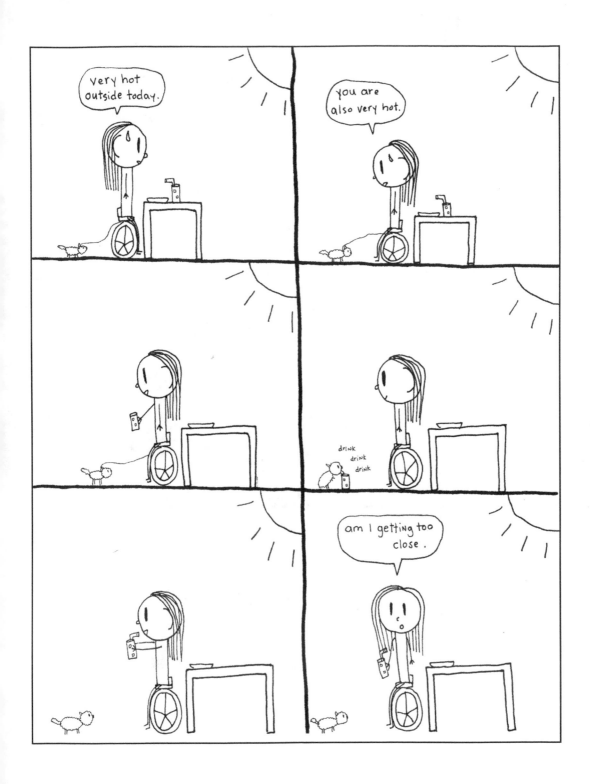

date me

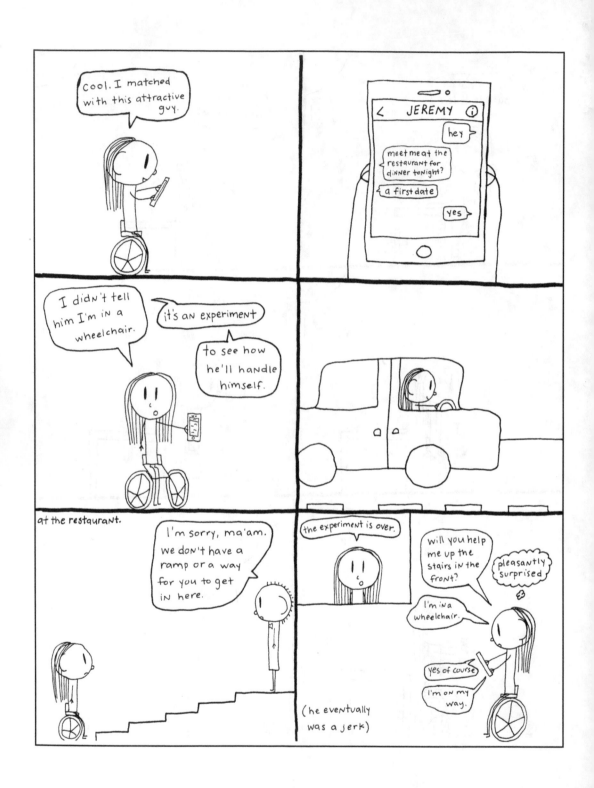

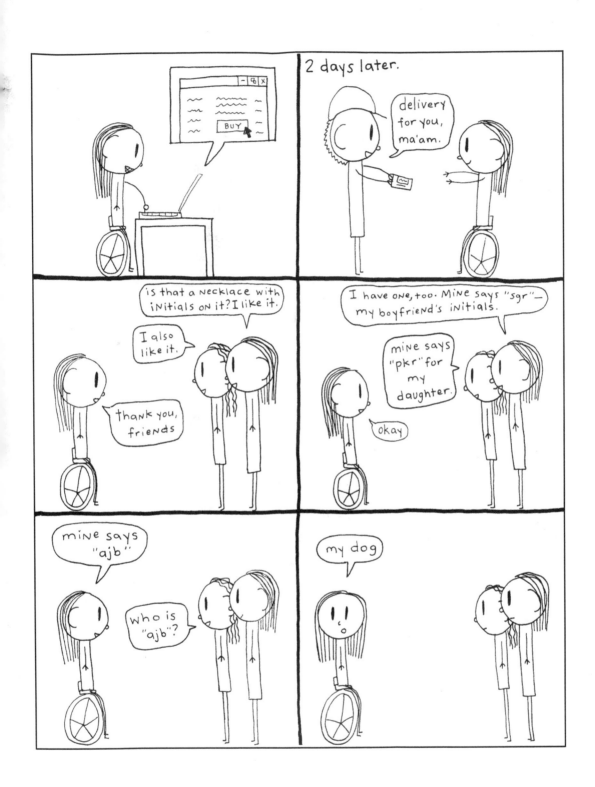

date me

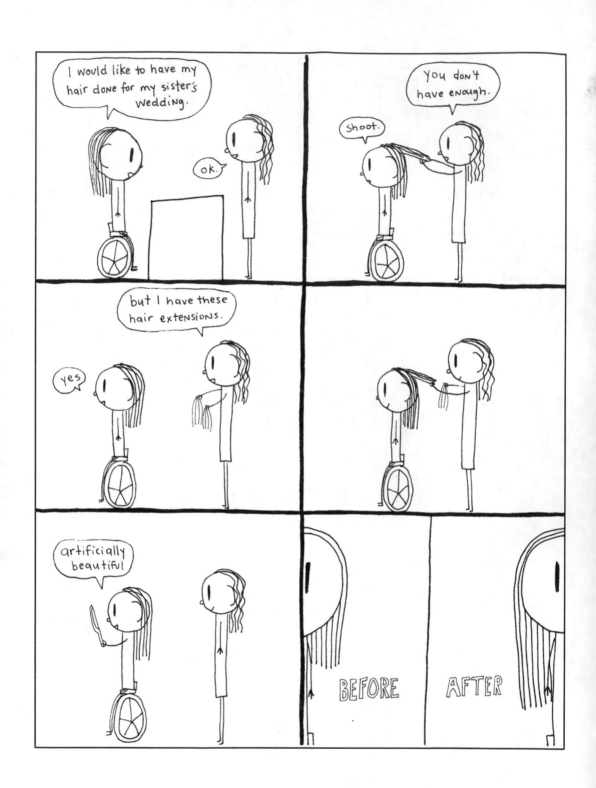

KRISTIN BEALE

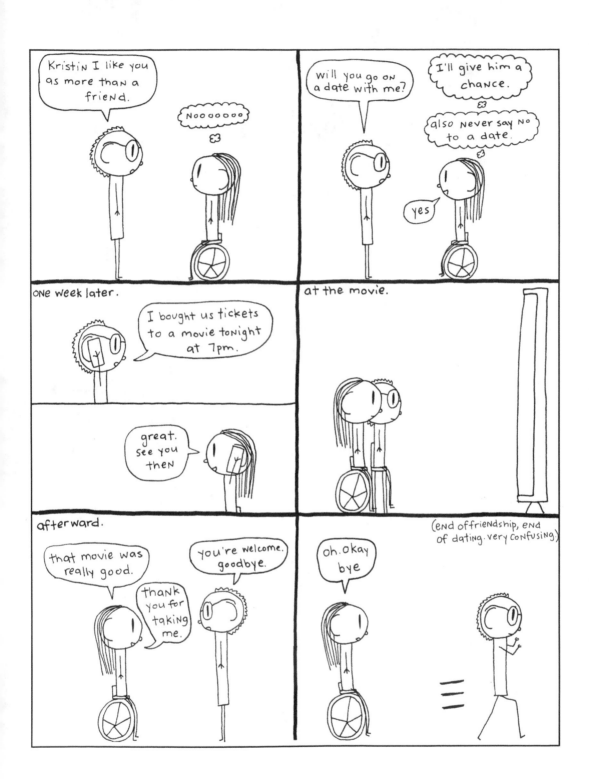

date me

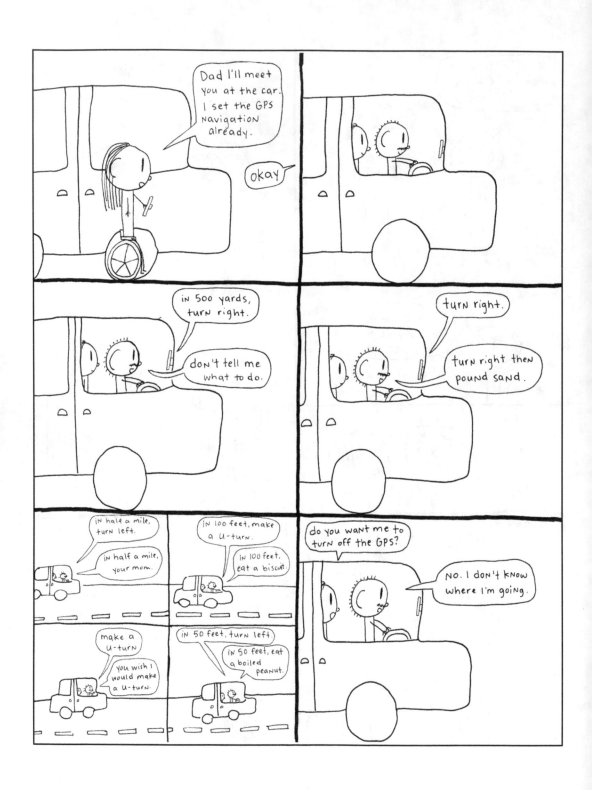

KRISTIN BEALE

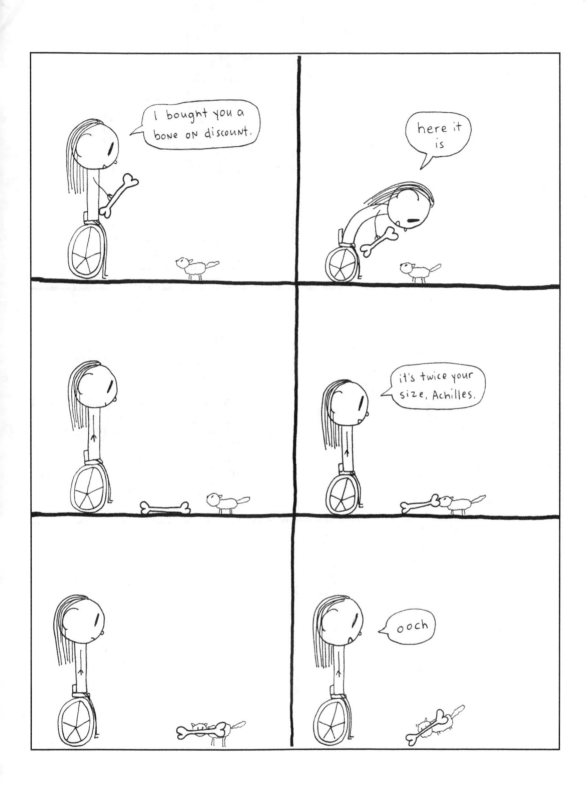

date me

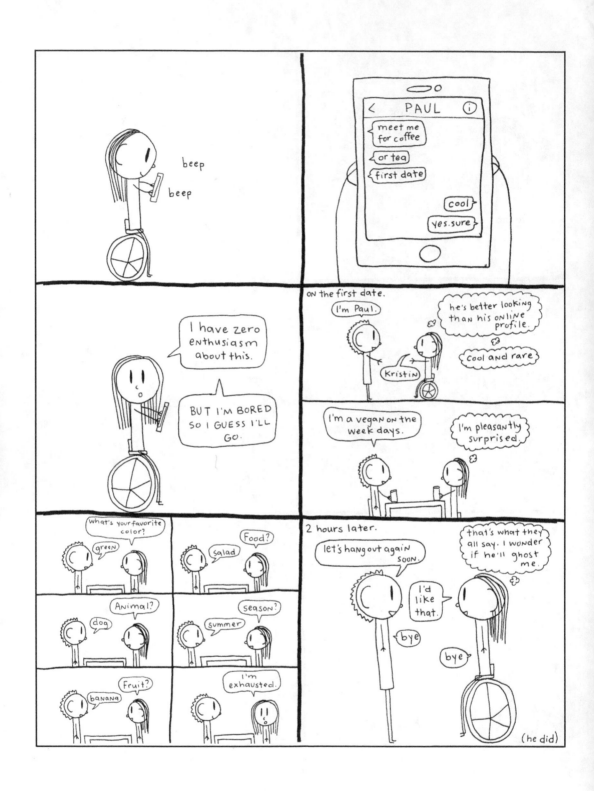

KRISTIN BEALE

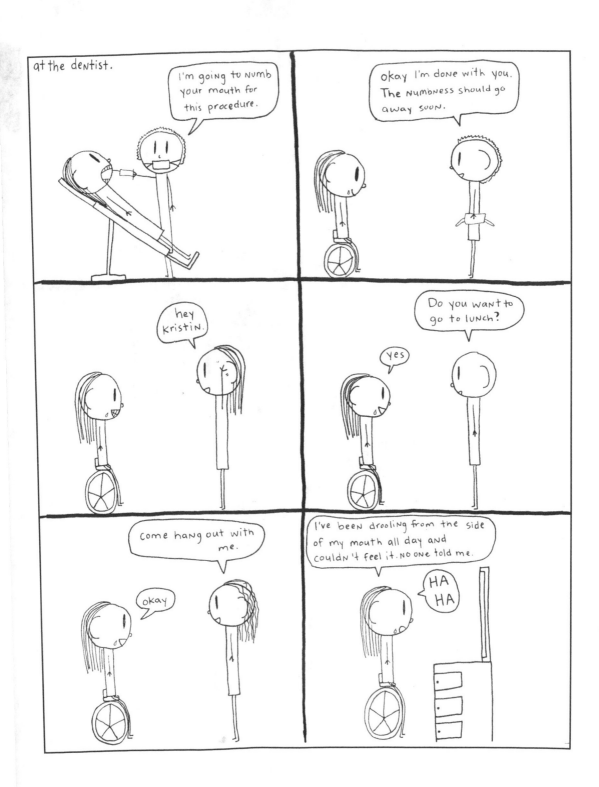

date me

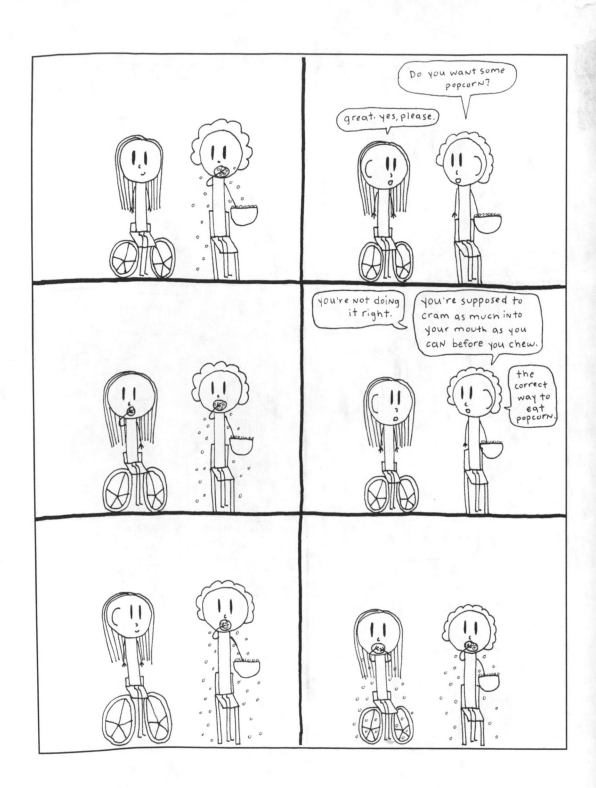

KRISTIN BEALE

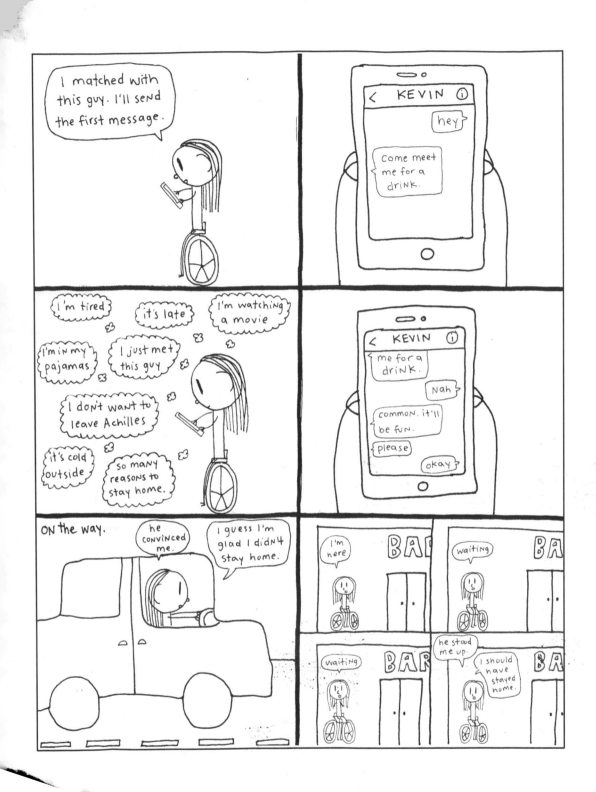

date me

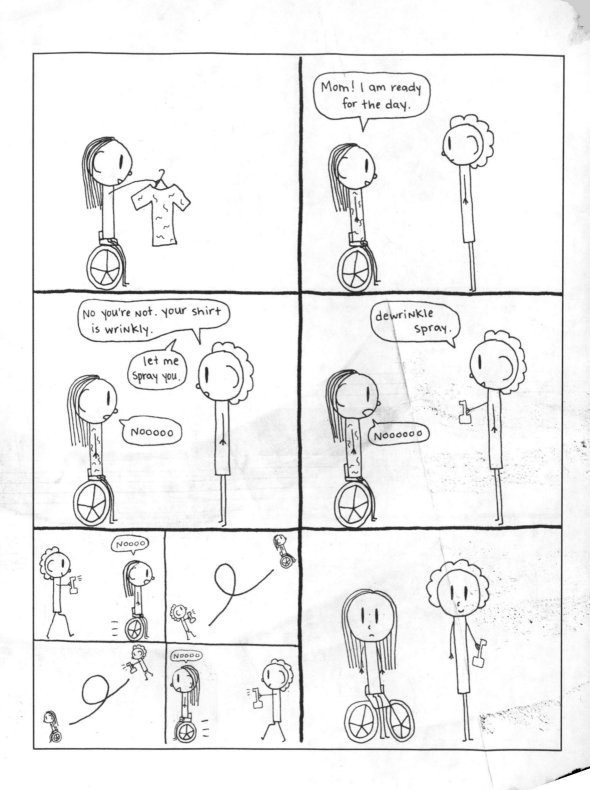

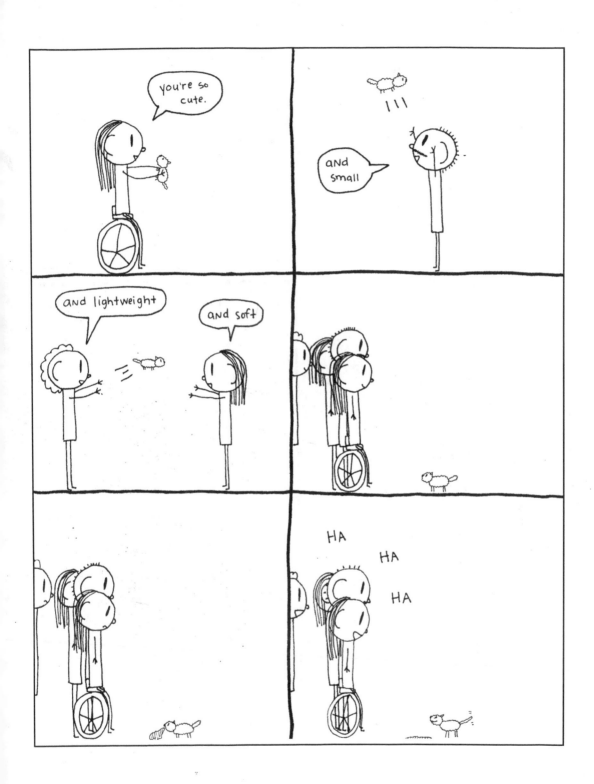

date me

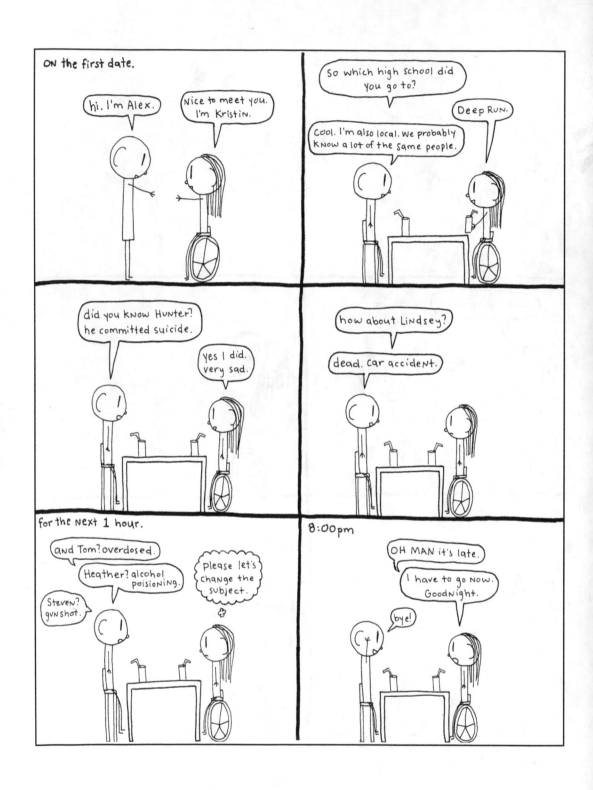

KRISTIN BEALE

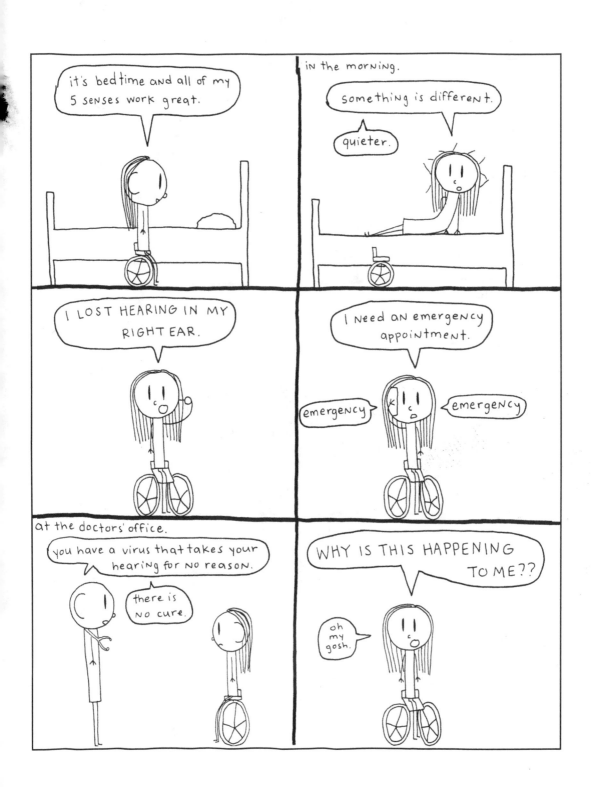

date me

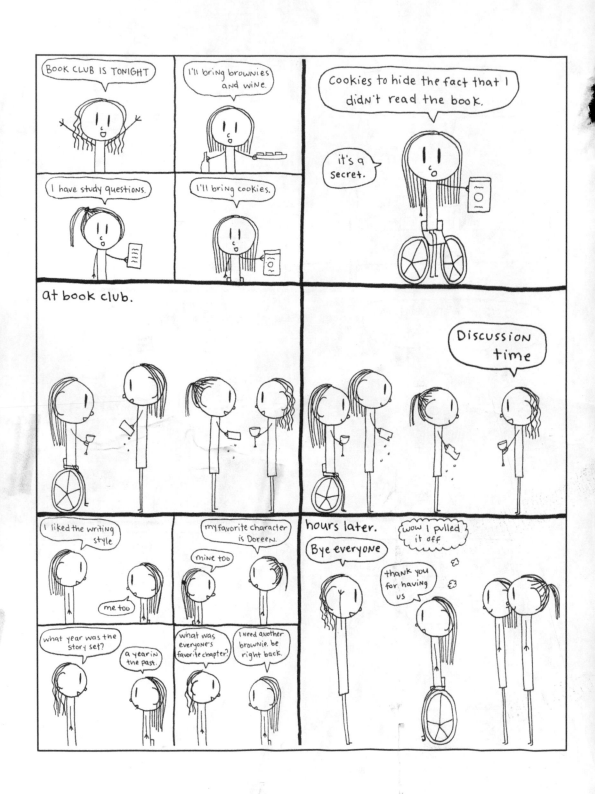

KRISTIN BEALE

86

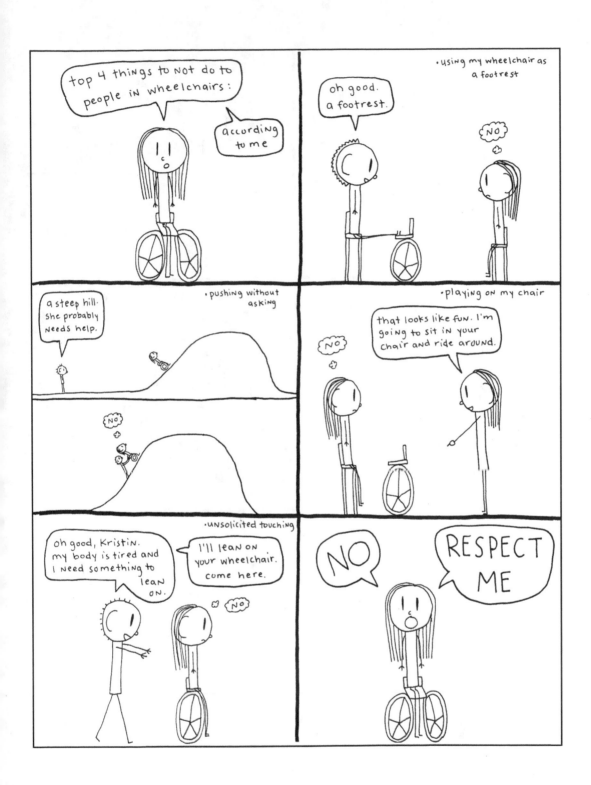

date me

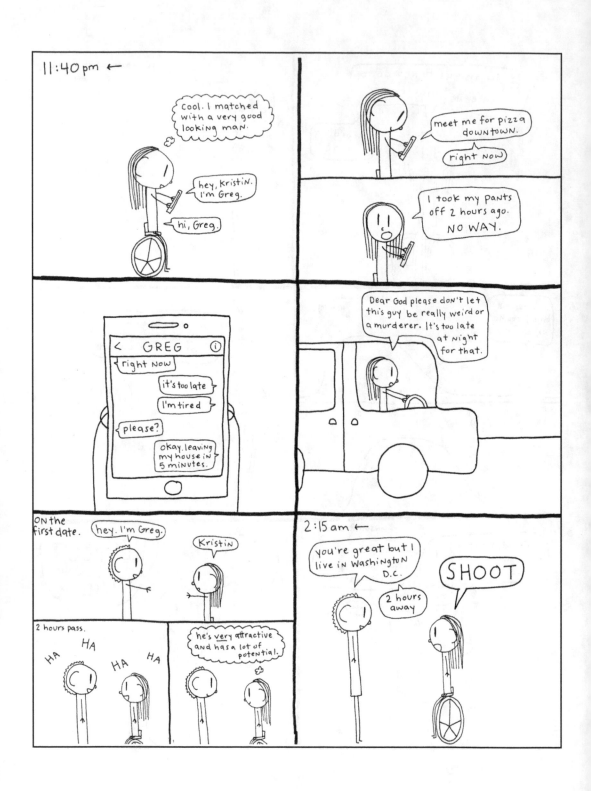

KRISTIN BEALE

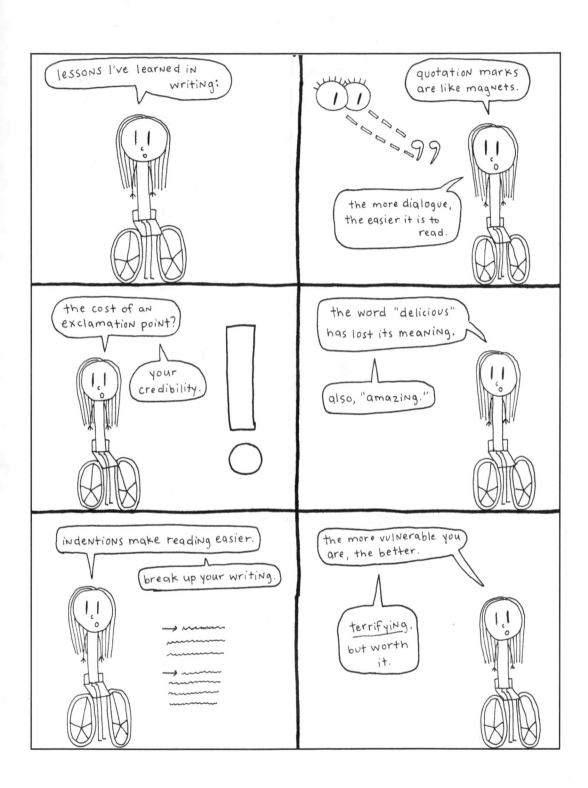

date me

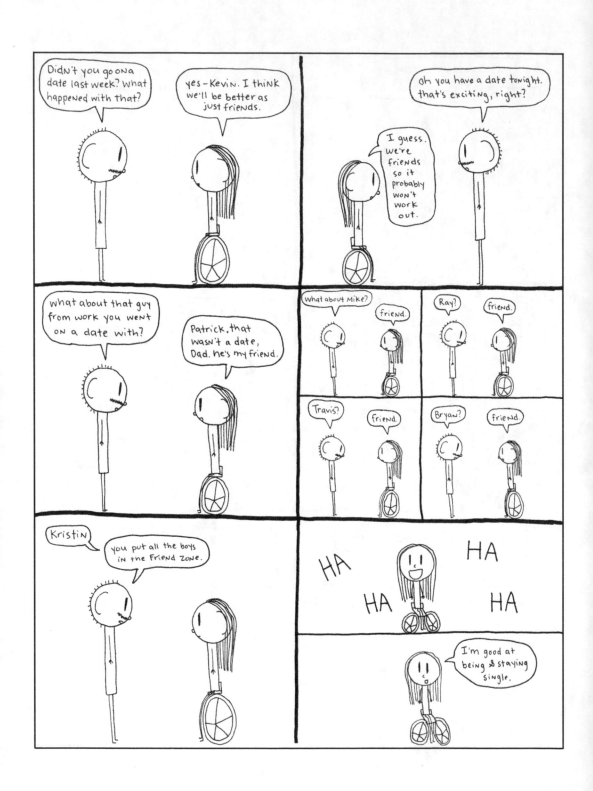

KRISTIN BEALE

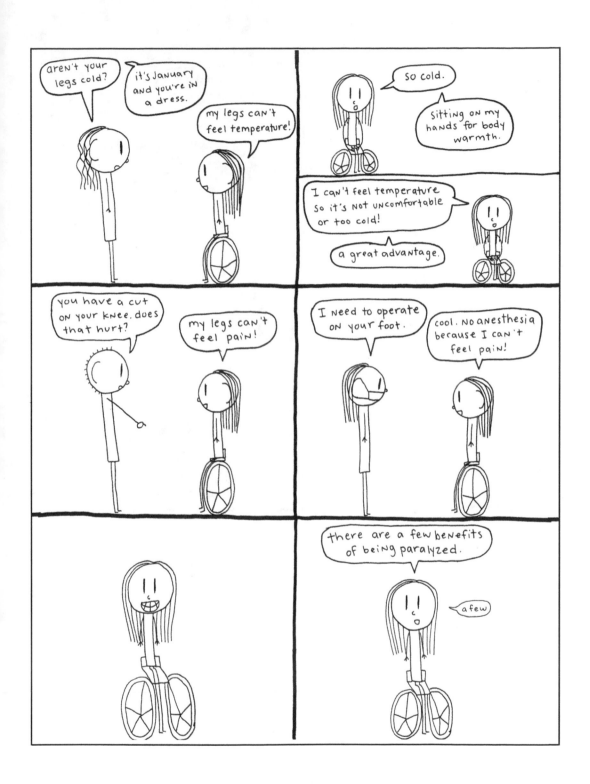

date me

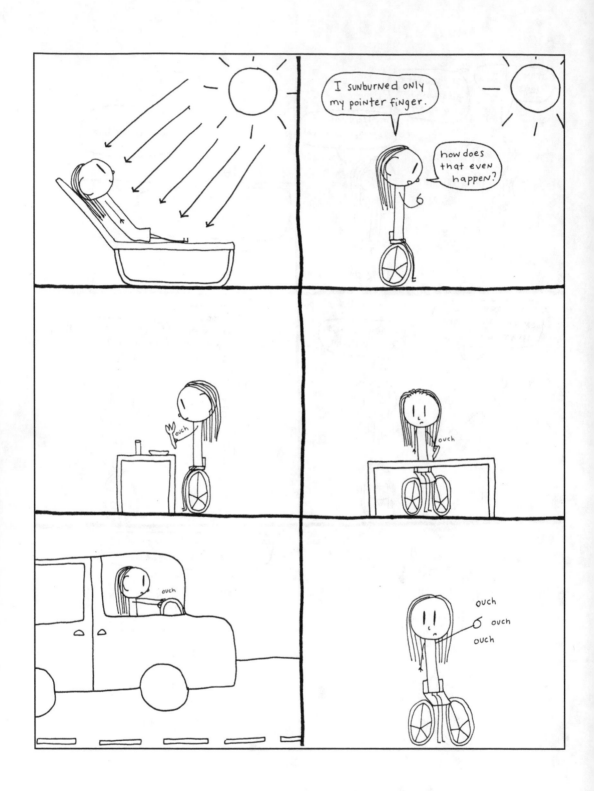

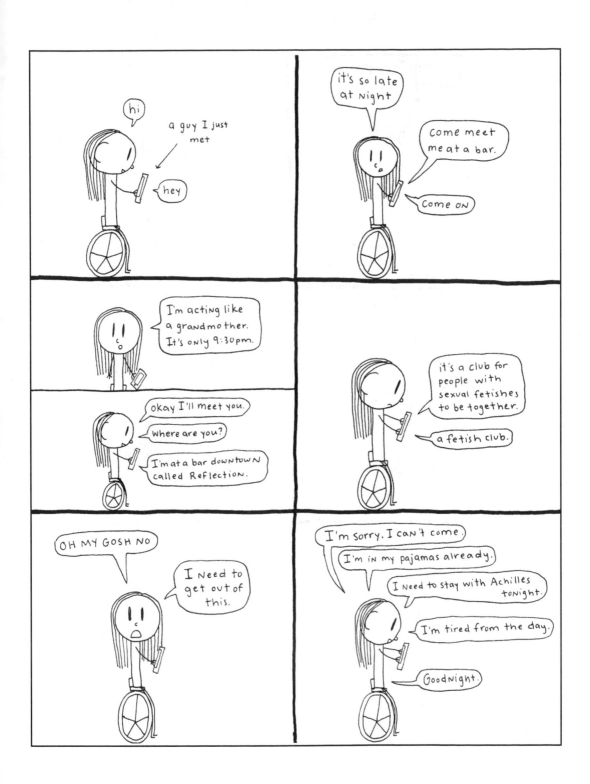

date me

93

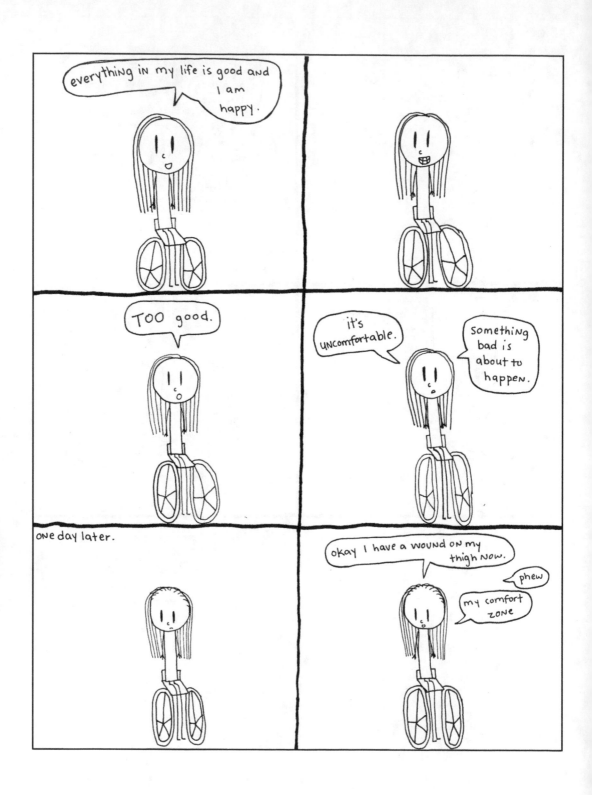

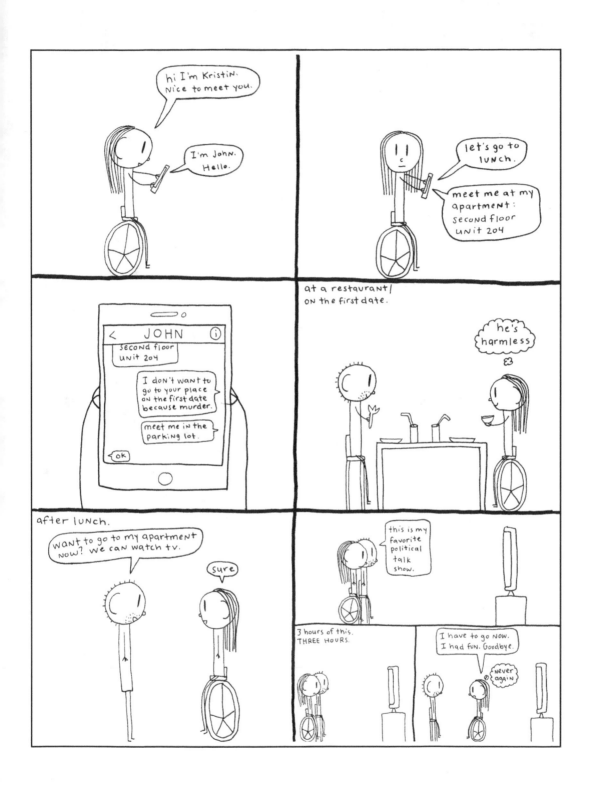

date me

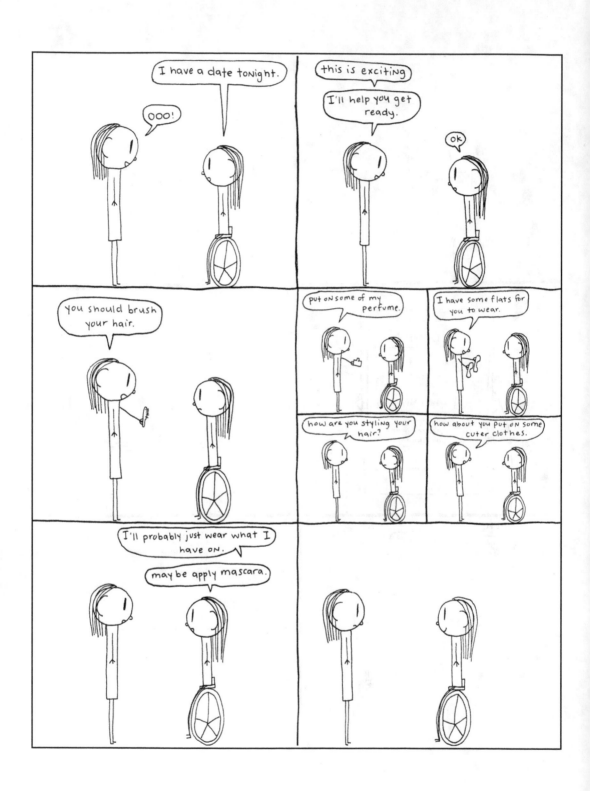

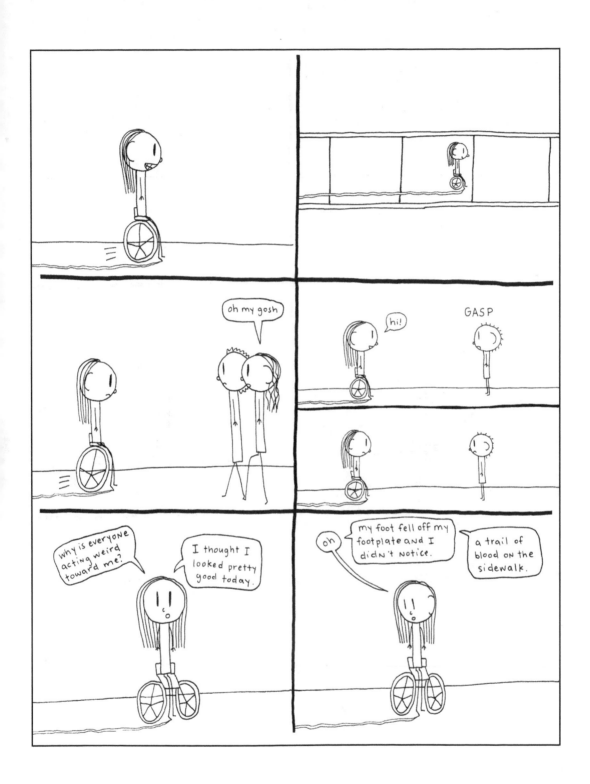

date me

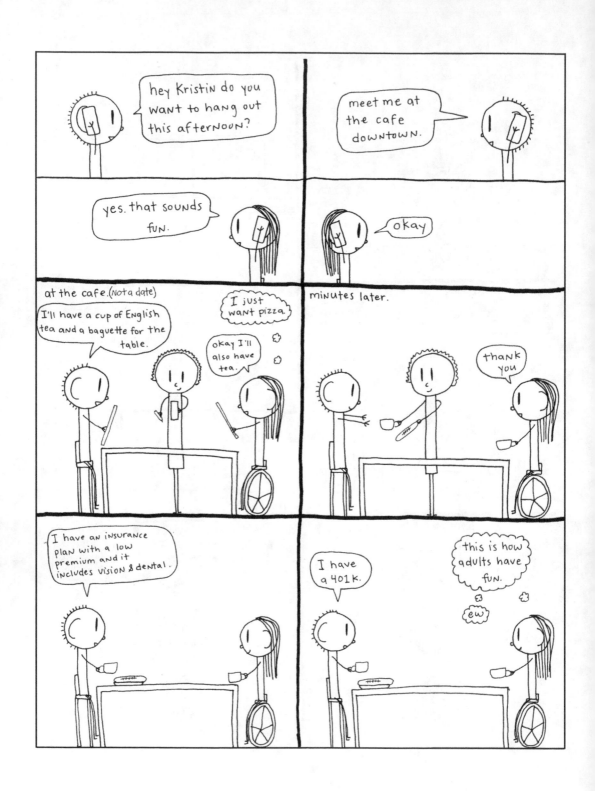

KRISTIN BEALE

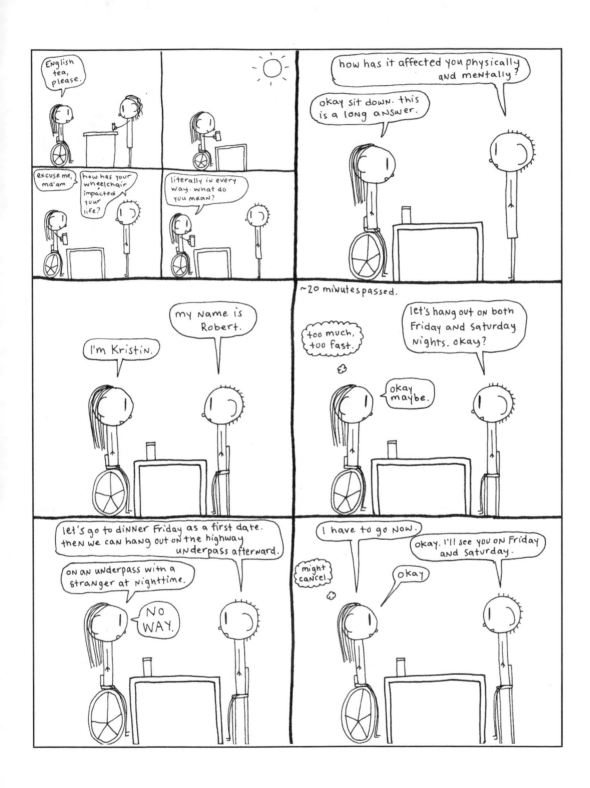

date me

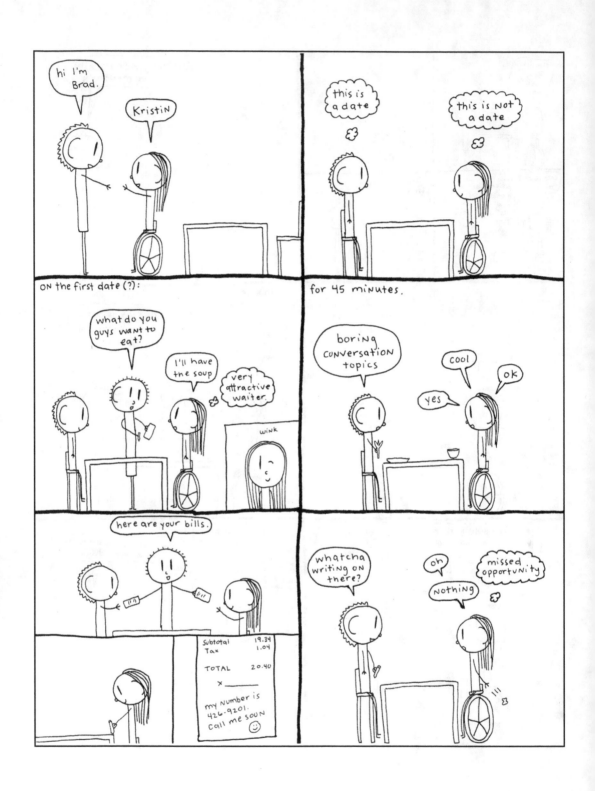

KRISTIN BEALE

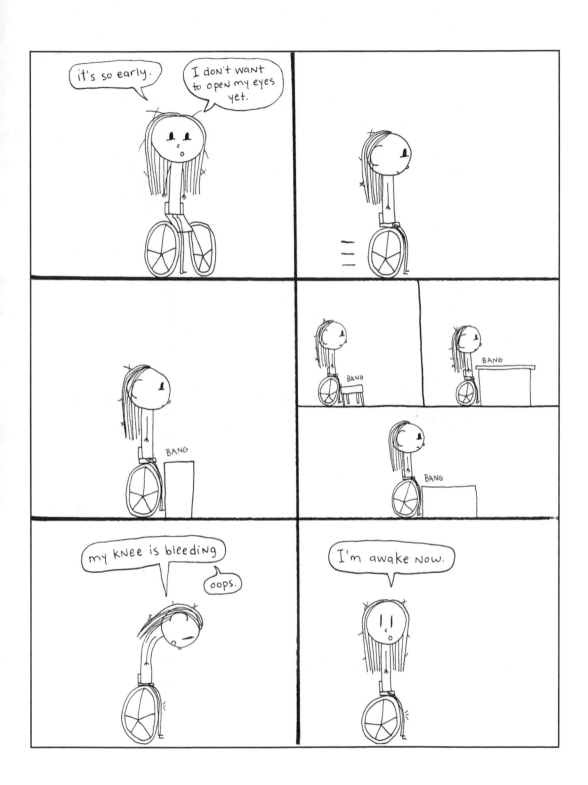

date me

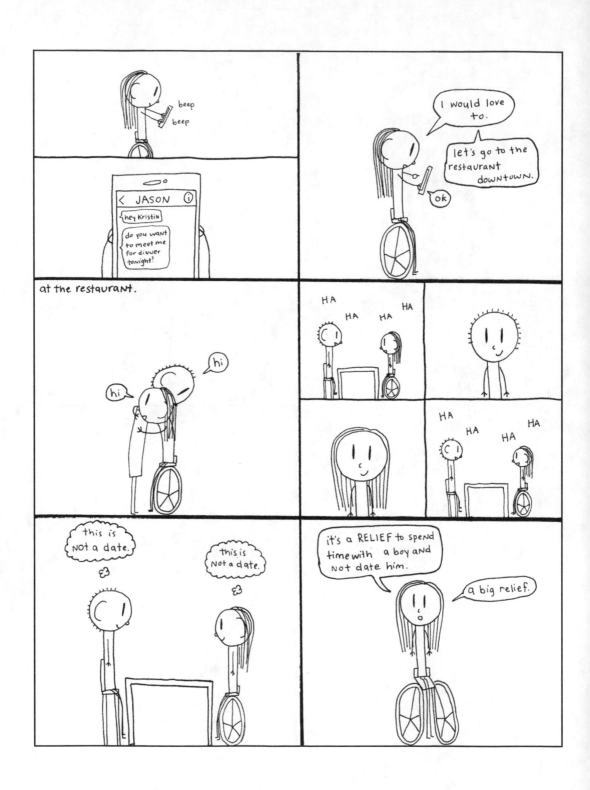

KRISTIN BEALE

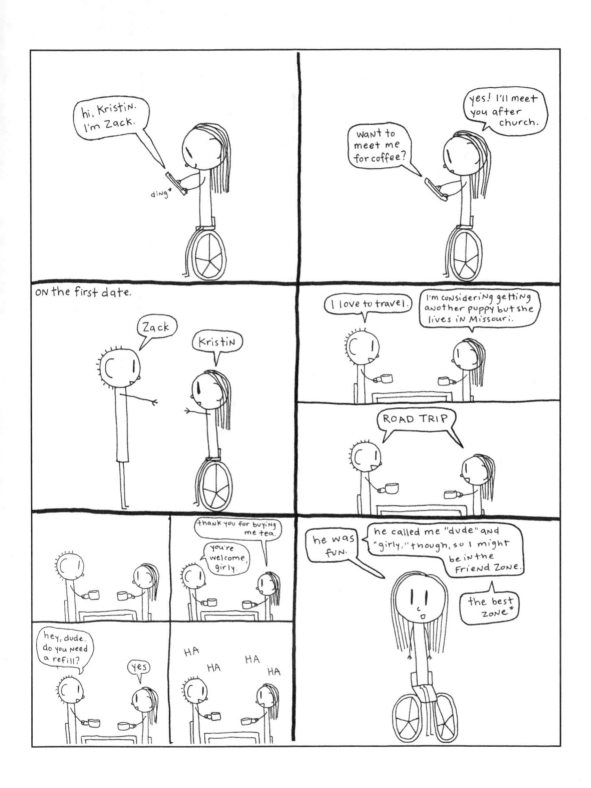

date me

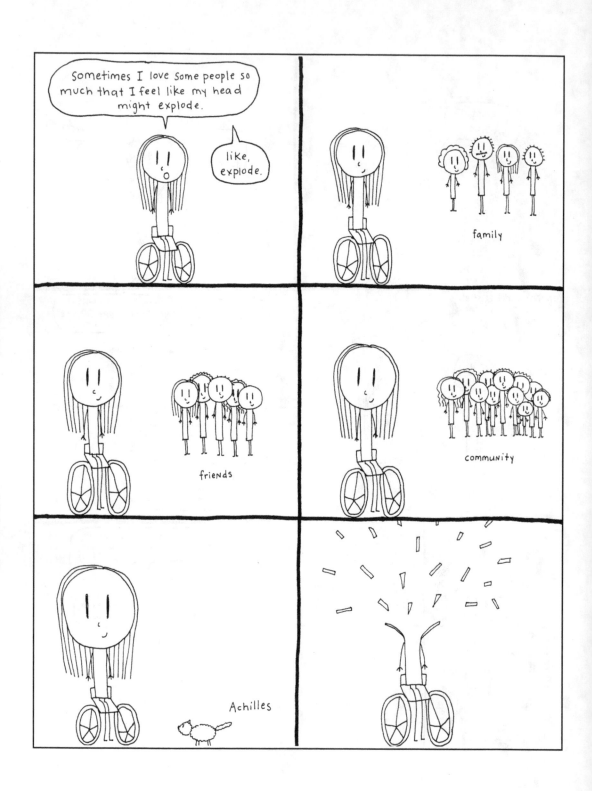

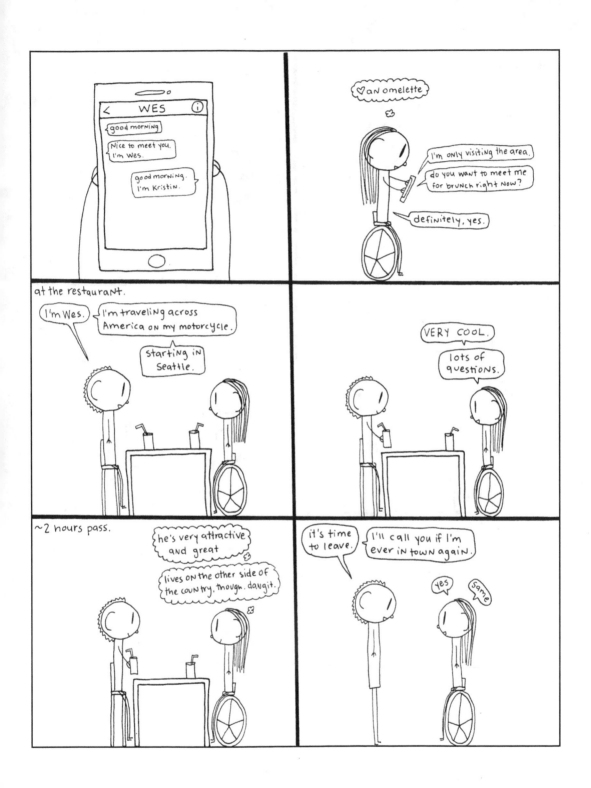

date me

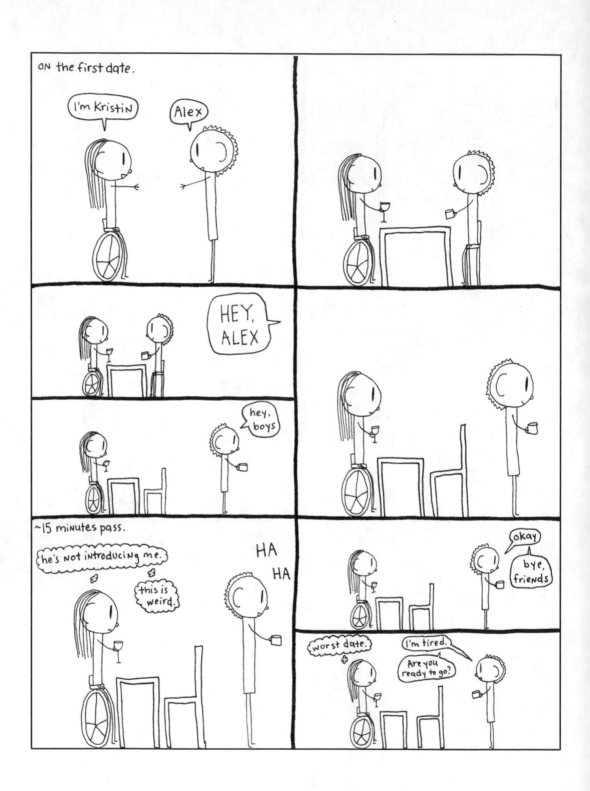

KRISTIN BEALE

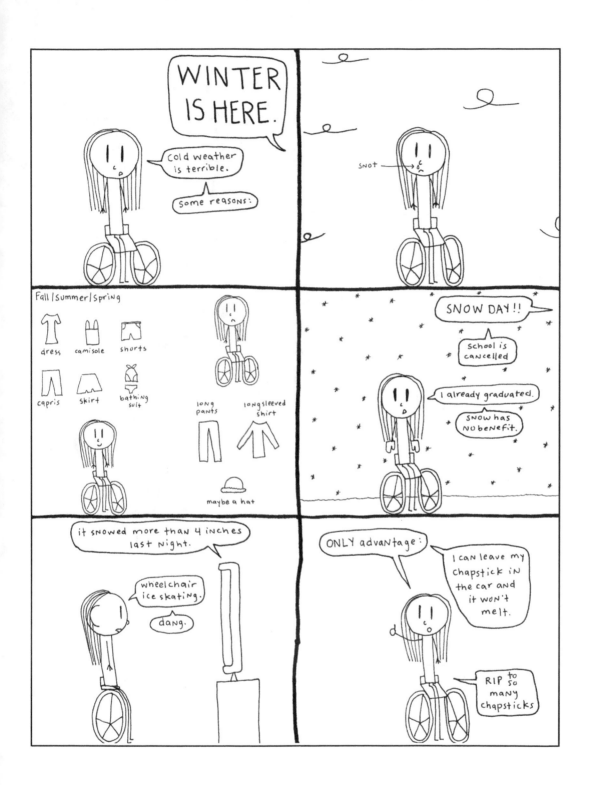

date me

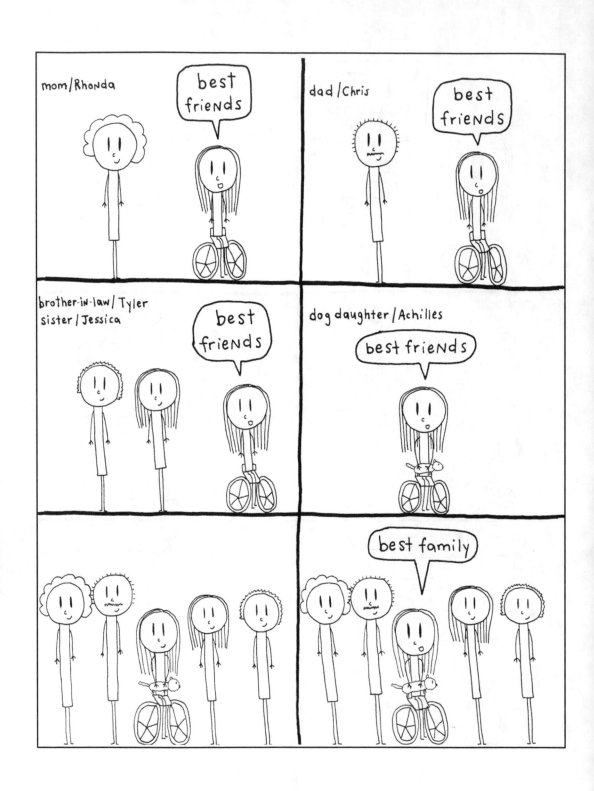

KRISTIN BEALE

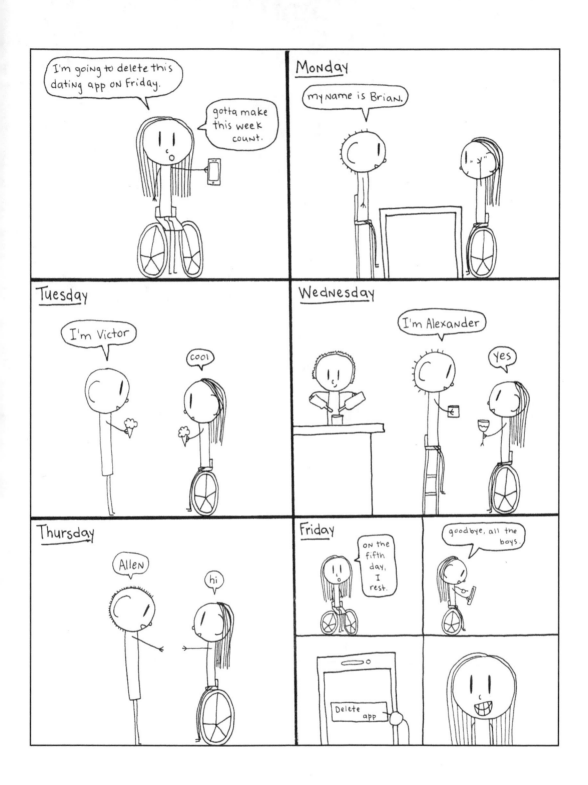

date me

Morgan James
Speakers Group

We connect Morgan James published authors with live and online events and audiences who will benefit from their expertise.

Printed in the USA
CPSIA information can be obtained
at www.ICGtesting.com
JSHW060056150824
68134JS00032B/2744